Peterborough Cathedral 2001–2006

from Devastation to Restoration

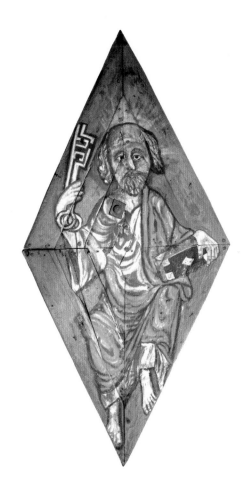

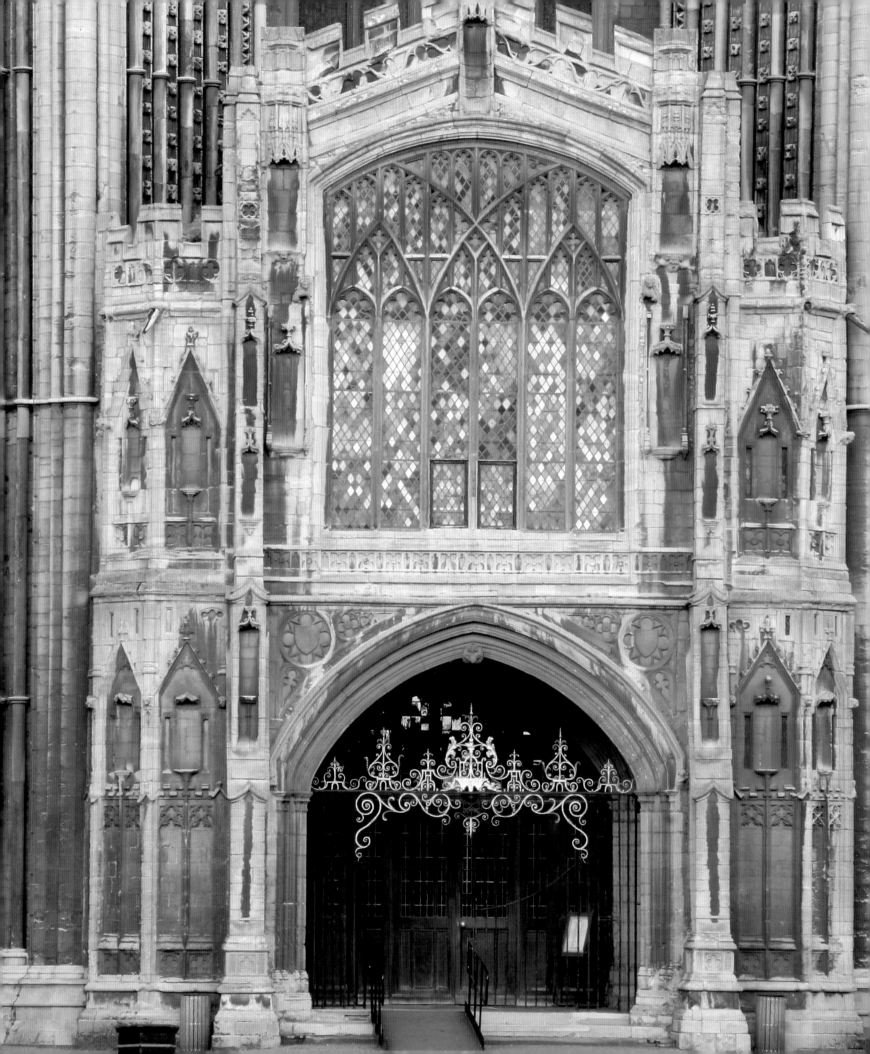

Peterborough Cathedral 2001–2006 from Devastation to Restoration

The Very Revd Michael Bunker,
Dean of Peterborough 1992–2006

Paul Binski, Professor of Medieval Art,
Cambridge University

Paul Holberton publishing 2006

First published for The Peterborough Cathedral Development and Preservation Trust
2006

With special thanks to the *Peterborough Evening Telegraph* for their support during the
restoration process and their permission to use their photographs in this book.

Thanks are also due for their assistance in the preparation of this book to
Elizabeth U. Knight
Canon Brian W. Long, MBE

ISBN 1 903470 55 8

British Library Cataloguing in Publication Data
A catalogue record for this book is available from the British Library

Produced by Paul Holberton publishing, 37 Snowsfields, London SE1 3SU
www.paul-holberton.net

Edited by Laura Parker
Designed by Roger Davies
rogerdaviesdesign@btinternet.com

Printed by Graphic Studio, Bussolengo, Verona

Page 6: Detail of the nineteenth-century lithographic drawing of the Nave Ceiling
by W. Stickland (see pages 80-81).

Contents

KENSINGTON PALACE

LONDON W8 4PU

Peterborough Cathedral has been a dominant feature of the townscape of this city for centuries. It very nearly suffered a devastating fire in 2001 but was saved by the fortuitous vigilance of the verger and the rapid response of the Peterborough Fire Brigade.

None the less the smoke damage done to every surface in the Cathedral meant that the meticulous conservation achieved in many areas, including the medieval timber painted ceiling, had to be repeated.

This book shows the determination that this great building should arise from this disaster even more radiant than before, in spite of the malice of the arsonist, and maintain its role as founder of this city, its chief historical monument and cultural exemplar of the spirit of former generations.

HRH The Duke of Gloucester KG GCVO

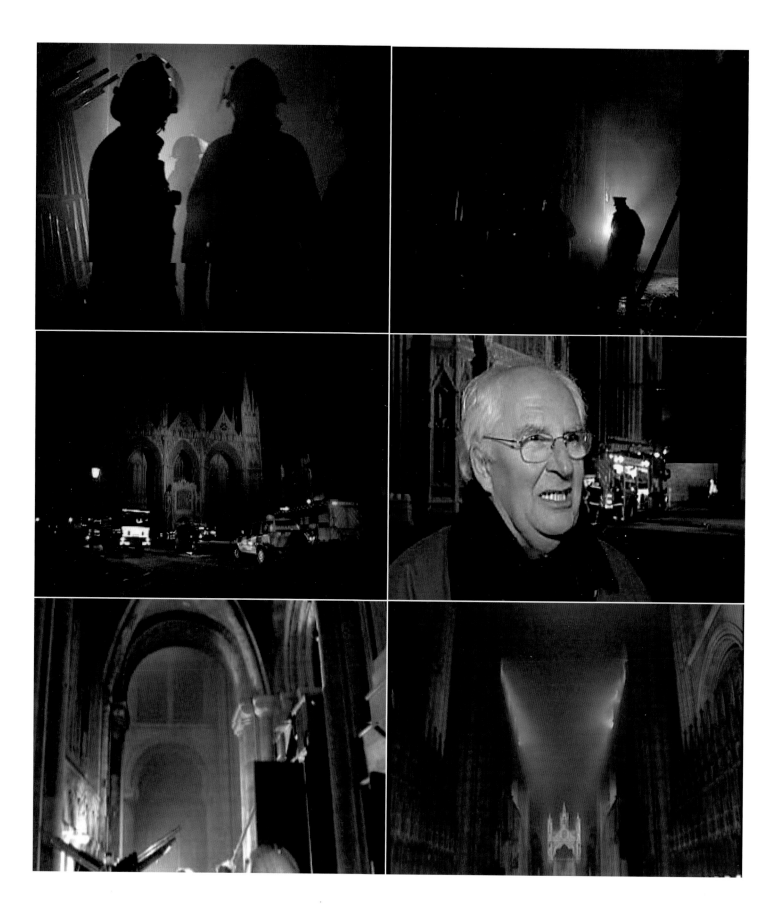

Preface

This book tells the story of how Peterborough Cathedral has recovered from the tragedy of the fire in 2001; how the restoration programme – then already in progress – was extended; how it was managed and paid for; and how it was completed, leaving this magnificent building clean and bright, and fit for many years to come.

Nobody is better qualified to tell this fascinating story than Michael Bunker, who retired as Dean in March 2006. As chairman of Peterborough Cathedral Trust, I have had the privilege of working closely with Michael; I know how much he loves this place, and how seriously he has taken his reponsibility for maintaining both its ministry and its fabric.

It was Michael who recognised the need to fund conservation and maintenance programmes in a systematic way. This led to the launch of the 1996 Appeal, whose £7.3 million target was reached by the end of 2000. Less than a year later, the fire came as a terrible shock to the whole Cathedral community – but to no-one more than to Michael.

As his narrative makes clear, however, it did not take him long to recover his sense of purpose: the Emergency Appeal was launched the next day. Its main purpose – which has been amply achieved – was to allow us to extend the conservation programme, making use of expensive scaffolding installed for the clean-up, and to carry out a major refurbishment of the organ at the same time as the fire damage was being repaired.

The fire also interrupted the conservation of the Nave Ceiling, leaving much of the work to be repeated. Now that this mammoth task has been completed we are immensely grateful to Professor Paul Binski for his authoratative account of the Ceiling's history, which forms an important part of this book.

Throughout the restoration, Michael's leadership has been exemplary. He found time to keep a clear oversight of all aspects of the restoration, whilst continuing the daily round of Cathedral worship – encouraging here and chivvying there, he kept things moving.

Five years in the life of a Cathedral that has been here for nearly 800 is 'like an evening gone'. But I believe its integrity for many years into the future has been assured by the events of those few years.

I hope you enjoy reading this book.

Jock Kennedy

Sir Jock Kennedy, GCB AFC
Chairman, The Peterborough Cathedral Development and Preservation Trust

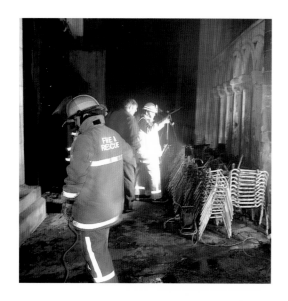
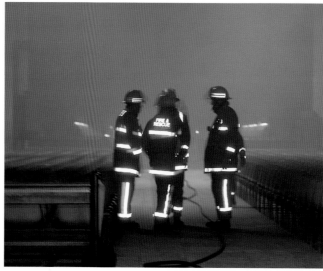

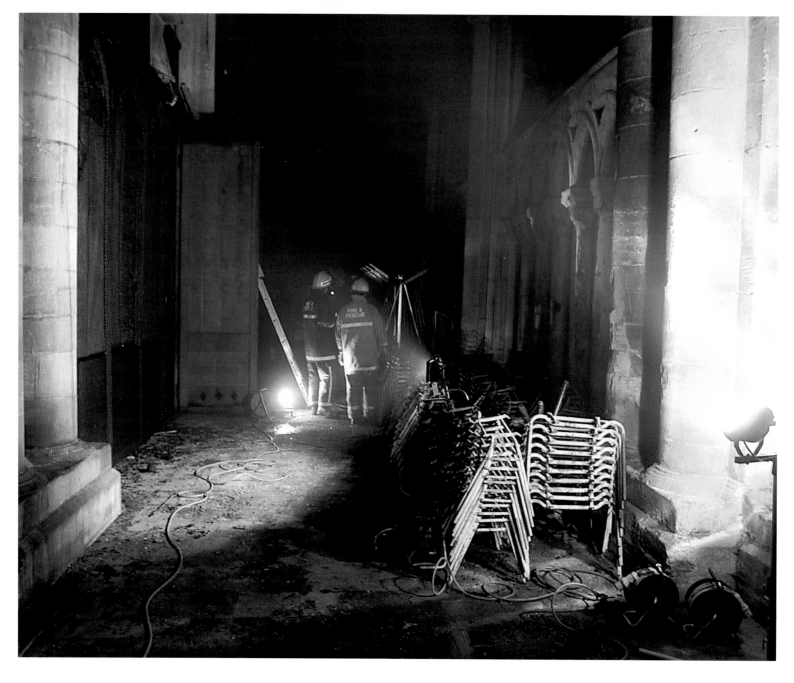

1/Fire! 22 November 2001

The Very Reverend Michael Bunker

LEFT ABOVE The night of 22 November 2001: firemen from the Peterborough brigade at the scene of the fire

LEFT BELOW The stack of plastic chairs that were at the seat of the fire

RIGHT Fire engines at the West Front on the night of the fire. Eleven engines in total came.

BELOW Plan of the Cathedral showing the seat of the fire in the North Choir Aisle

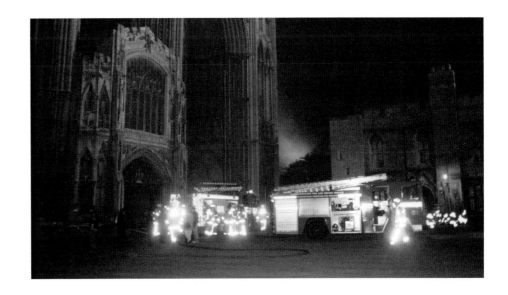

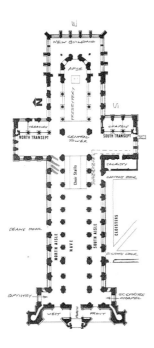

"The Cathedral's on fire!" That was the telephone message that brought me hurrying back to the Precincts and the Cathedral on the night of 22 November, five years ago, in 2001. There I was met with a very disheartening scene. There were fire engines, police cars and firemen, and police in their yellow day-glow jackets. It all looked very serious indeed. The Cathedral floodlights were revealing not just the majesty of Peterborough Cathedral but black smoke issuing from the vents along the length of the Nave roof. It looked as if the whole of the Cathedral was on fire. I arrived at the West Front where the great West Doors were open. The lights inside the Cathedral were still on but were only just visible through the thick black smoke which had filled the entire building.

As I moved forward to try and get a better view and survey the situation, I met one of the firemen coming out of the Cathedral. He was wearing yellow protective clothing, helmet and breathing apparatus; he had obviously been working

ABOVE View from the organ console: the blackened arch indicates the seat of the fire.

RIGHT View of the fire-damaged North Choir Aisle from the South Tribune Gallery

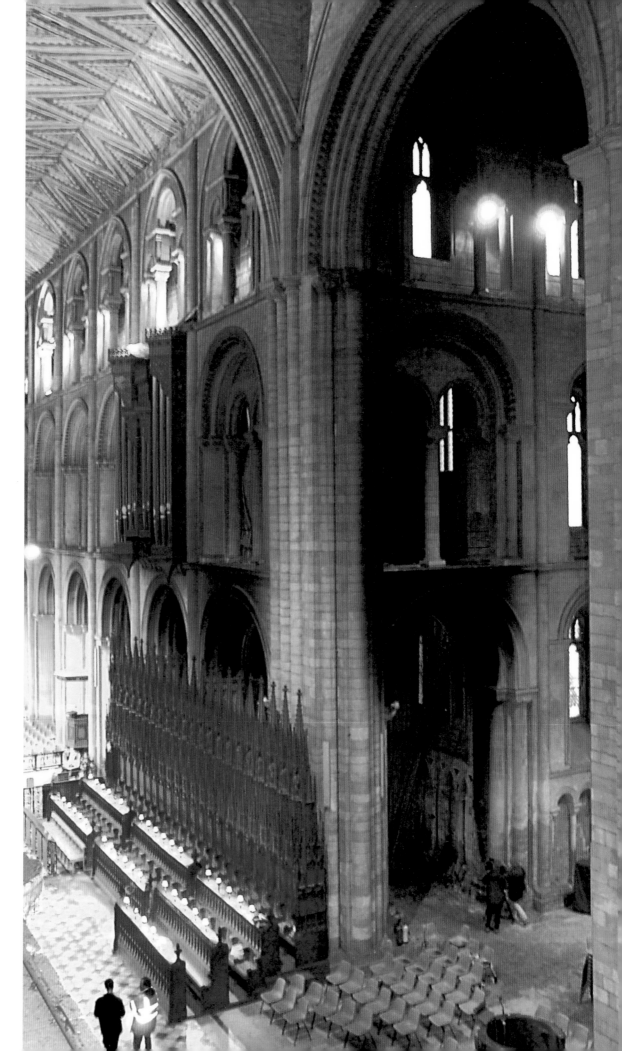

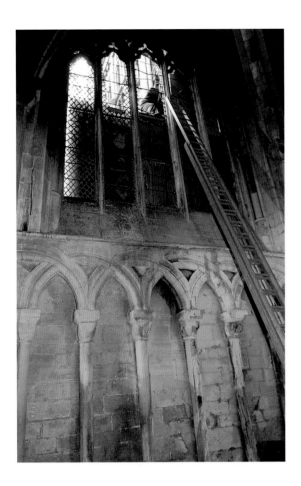

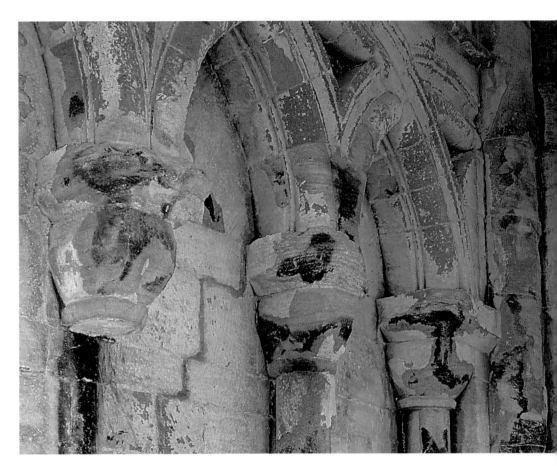

at the seat of the fire. He recognised me, lifted up his visor and explained: "It's the plastic chairs". "Good", I replied, clearly in shock, thinking that he was telling me the worst of the news and that all we had lost was a number of grey plastic chairs which normally covered the Nave and were stacked in numerous nooks and crannies in readiness for big occasions. They were practical, but grey, uncomfortable and ugly.

My reaction of relief was misplaced. What I was actually being told was only that the plastic chairs were the root of the fire. It had started in one particular stack of about two hundred chairs in the North Choir Aisle, one of the darkest spots in the Cathedral. There is a large, clear-leaded window above, but it is about eight feet off the ground and, being on the north side, lets in little of the day's bright sunlight. The Choir Organ and Stalls, on the other side of the aisle, prevent much light from penetrating from the south side. Thus the North Choir Aisle was infrequently used by visitors and was used, instead, to store plastic stacking chairs. Of course, we have since learned our lesson and rid the Cathedral of all these chairs, replacing them with more attractive and comfortable folding seats made of fire-retardant materials. They are stored on trolleys, out of reach of the general public, in newly built cupboards located in strategic positions around the Cathedral. No

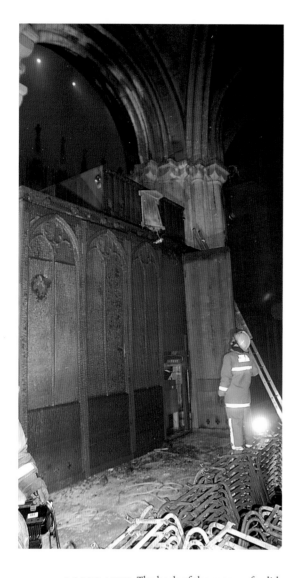

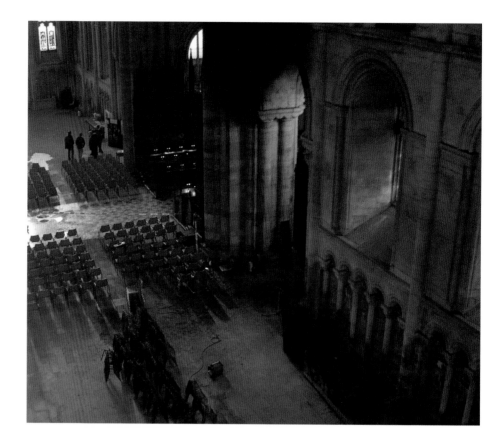

ABOVE LEFT The back of the organ, of solid oak, charred rather than bursting into flame.

ABOVE RIGHT Looking down on the North Transept and Crossing. The fire broke out in the North Choir Aisle, on the right.

such provision was in place on the night of the fire. According to the fire service investigators, an arsonist must have placed lighted votive candles amongst the stacked chairs. Eventually the candles started to melt the plastic, causing a liquid fire to ensue. It was the burning liquid plastic that had produced this thick, black, oily smoke which had so quickly filled the Cathedral and was to cause so much work for the restorers.

The clean-up was to be a massive operation. However, the fire left more in its wake than soot. The stone arcading in the North Choir Aisle, near the seat of the fire, was badly damaged by the heat; layers of stone had peeled away like those of an onion (see illustration on preceding page). Part of the Cathedral Organ is positioned on the floor of the North Choir Aisle. Thankfully, it was faced in heavy oak panelling, which proved to be excellent insulation from the worst of the fire. Though all of the panelling had to be replaced, the organ itself suffered only slightly (see further below, pp. 67ff).

The window above the seat of the fire was completely destroyed. Fortunately, it did not contain any stained glass and was of no great historical value. Still more providential was the fact that it was a leaded window and in that particular

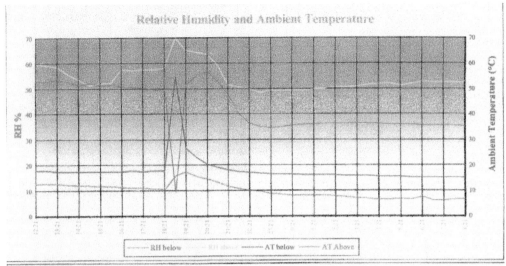

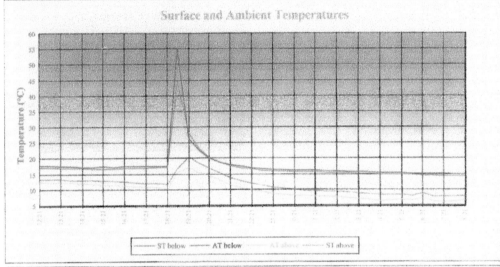

ABOVE The window above the seat of the fire (seen from outside) – through which the fire was spotted and extinguished

ABOVE RIGHT Data from the heat and humidity sensors in the ceiling illustrating critical levels of heat on the night of the fire

position. When the fire was at its height, the Central Tower acted as a chimney, funnelling the flames and the smoke towards our vulnerable wooden ceiling. We subsequently learned, from monitors that had been positioned on the Nave Ceiling, that this had come very close to being set alight by heat from the burning plastic chairs (see illustration above). These monitors had been placed on the ceiling during the first phase of the restoration, not in case of fire, but to provide data about humidity and temperature required for the care and management of this ancient wooden ceiling. As can be seen from the illustration, the boards of the Nave Ceiling had been heated to a critical level by the flames and smoke: the ceiling panels were on the point of catching fire. If this had occurred, the whole

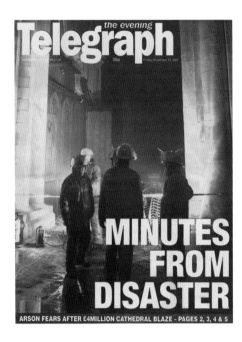

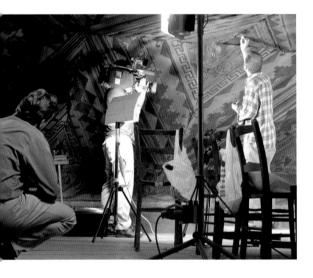

TOP The front page of *The Peterborough Evening Telegraph*, 23 November 2001

ABOVE Up in the Nave Ceiling with Mark Perry, a film crew shoot a news piece about the fire for BBC Look East.

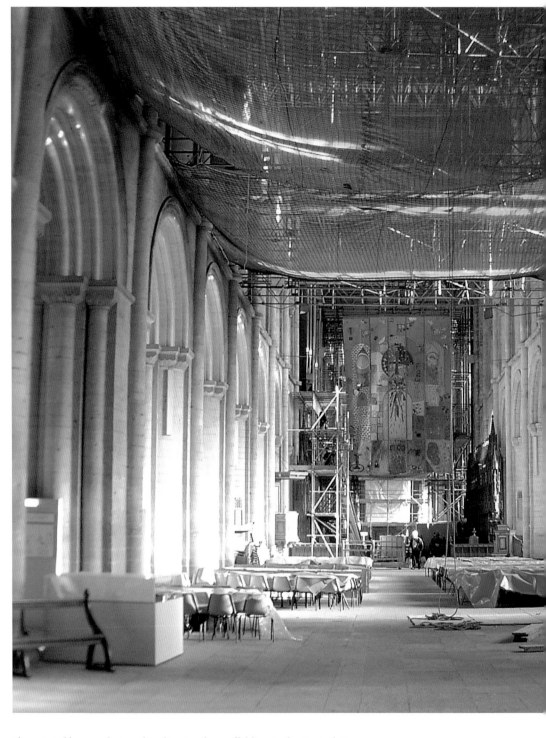

The painted banner designed to disguise the scaffolding in the Central Tower

ceiling would quickly have been engulfed in flames, and the resulting damage, both here and elsewhere, would have been catastrophic. We had been just minutes away from the virtual destruction of the whole Cathedral. Thank God, the heat from the fire caused the lead in the window to melt and, as a result, the glass fell out. This, in turn, caused the flames to be sucked outside instead of inside and up towards the Nave Ceiling.

It was through this window that one of our vergers, who was on his way home, saw the light of the flames. He immediately called out the fire services. His prompt action and the quick response of the fire brigade saved the Cathedral from destruction. The window had yet another service to fulfil. Situated as it was, just above the seat of the fire, it enabled the firemen to get to the most strategic position to tackle the flames, and to extinguish them from outside. The consequences would have been far worse if they had been obliged to bring all their equipment through the Nave of the Cathedral.

Though the damage caused by the burning plastic chairs could have been worse, the effect of the smoke and the soot was nonetheless considerable. The smoke reached every level and corner of the Cathedral. Every surface was coated in a sooty deposit which was to cause immense problems. It meant the Cathedral would have to be full of scaffolding for a number of years to enable the cleaning process to take place. The smoke and the oily deposit even pervaded the organ chamber. The organ, therefore, had to be dismantled for a thorough cleaning and was not to be used for worship again until April 2005.

The effect of the fire was not just material. It occurred after a long period of intense activity in the Cathedral. I was hoping that the future might be less frenetic and that I would be able to enjoy my last few years as the Dean of this great Cathedral in calm, focusing on the worship and mission of our church. It seemed my hopes were being dashed. While the whole Cathedral was covered in scaffolding and filled with cleaning materials, how would we be able to experience a period of growth and development in our worship and ministry? And yet the impossible happened. In the early days following the fire, people came in greater numbers to our worship seeking to express their concern and solidarity with us in our trial. Others came out of curiosity, to see the damage and how we were coping in the circumstances. The fire also had the effect of putting Peterborough Cathedral in the news. The local paper, radio and television stations all gave us excellent coverage. Never had the Cathedral enjoyed such national and, indeed, international media coverage as it did as a result of the fire. The Mayor of Peterborough was on holiday abroad when he learnt of the fire from the Spanish television news.

Cathedrals are well known for their long-standing ability to uphold the ancient

Canon (now Bishop) Stephen Cottrell
celebrating the Eucharist in the Apse Chapel

traditions of the Church, and their congregations tend to be rather conservative. They are not usually known for their ability to introduce and develop radical and creative worship. However, the period of restoration following the fire was one of just such activity. We were forced, by the erection of scaffolding and the cleaning and repairing process, to develop a more flexible approach to worship. As we were constantly being displaced and compelled to move around the Cathedral, we had to be creative in our use of space and cultivate the ability to ignore the tons of scaffolding around us. At one period the whole of the Central Tower was scaffolded from floor to ceiling, creating an ugly backdrop to our worship in the Nave. So Canon, now Bishop, Stephen Cottrell provided an opportunity for our worshipping families and anyone from the general public to come into the Cathedral to create a banner, not just to adorn and hide the scaffolding, but also to give a message to all who saw it (see illustration on preceding page). It was a great piece of creative evangelism. And this is but one example of many similar activities that took place during these years. Thankfully, we had two Canons who were gifted, responsive and inventive enough to be able to grasp the positive aspects of the consequences of our catastrophe. Even before we called upon God for his help in this situation, he provided us with Canon Bill Croft and Canon Stephen Cottrell, who were able to face the challenge and turn trial into opportunity.

It is remarkable that, despite the fact that the Cathedral resembled, for several years, a building site rather than a place of worship, morale amongst the leadership of the Cathedral, its staff and its worshipping community was really very high. Though the early service on the morning after the fire had to take place in the Deanery, from that time onwards, during the whole of the restoration period, it was 'business as usual'. We had to manage for three years without our great Hill Organ, and yet this was a period of some very creative music making. The fact that our temporary electronic organ was tuned to concert pitch was a great help. Our musicians, led by Christopher Gower, the Master of the Music at the time, could easily have sunk into survival mode but, instead, they saw our predicament as an opportunity to develop the music of the Cathedral, and to consider what could be done with the Hill Organ during its cleaning process that might improve our music making for the future.

2 / The Emergency Appeal

Once the fire had been extinguished, the smoke began to dissipate. By the next morning all that remained was a black haze that filled the Tower; the rest of the smoke had gone, and the scale of the problem we faced could be seen. It was at this point that I began to realise the immensity of the task ahead.

Peterborough Cathedral is a vast building. Most visitors who enter through the West Door and view the interior for the first time are amazed at the stunning grandeur of the place. The uninterrupted view from west to east, the height from the floor to the medieval ceiling, the size and scale of the supporting columns, and the length of the building from the West Door to the High Altar, understandably leave one overcome by the vista. This is one of the 'wow factors' of

Skeletal remains of plastic chairs after the fire had been extinguished

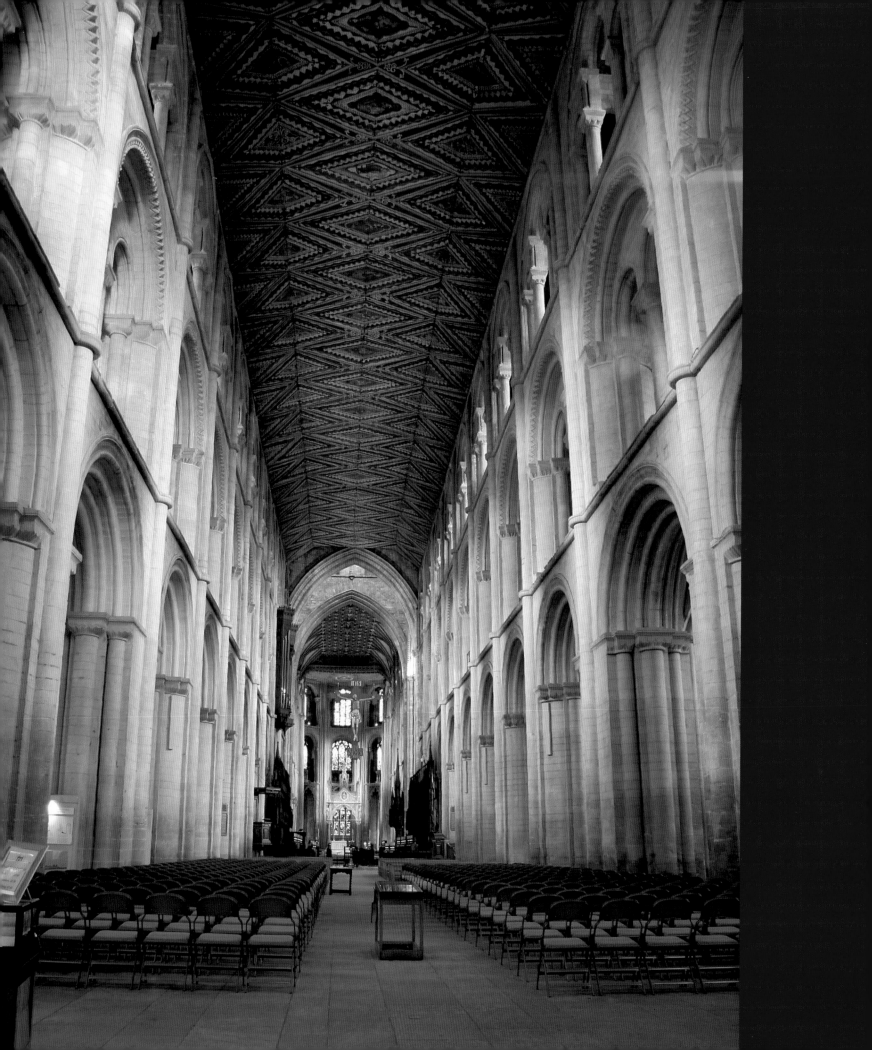

Views from the Nave
looking towards the
High Altar and Choir

Logo for The Company of St Peter,
established to raise funds for the Cathedral

Peterborough Cathedral. But on the morning after the fire, my reaction was very different. Everything looked grey and black – an appearance only worsened by the dull, grey light of that November morning. There was a horrid smell of burnt plastic in the air and everything was covered in the black, greasy film. It was a most awful sight and experience. The reality and scale of the effects of the fire were beginning to dawn on me. A visit to the seat of the fire in the North Choir Aisle further drove this home. The window was gone; there was water everywhere – left by the valiant efforts of the fire brigade in extinguishing the fire; only the skeletons of the plastic chairs remained, their frames still intact but their seats gone. The oak screens that encased the Choir Organ had been removed by the fire brigade in order to check that the fire had been completely extinguished. The sight of this part of the organ forcibly made it plain that the Cathedral Organ would have to be completely stripped and dismantled and would not sing again for a significant period of time. I slowly began to accept that life in the Cathedral would be drastically altered and that perhaps the fire would have an abiding effect. Only time would tell.

There was, however, an even worse realisation that dawned on me just before people began to arrive to see the scene that had been reported on television and radio and in the newspapers – the realisation that the damage caused by the fire would cost a great deal of money to put right. Had we paid this year's insurance premium? Was the cover we had going to be sufficient? Would I have to start again to raise yet more money for the Cathedral? All of these questions jockeyed for position in my mind. What was I going to say to people as they came in to view the scene? What was I going to say to the media who, I knew, would be coming to speak to me that morning? What was my own reaction to the past twelve hours and how was I, and how was the Cathedral, going to face the challenge that lay before us? The damage done to the Cathedral was very serious and would cost a substantial amount of money. How were we going to cope with that?

The backdrop to this question needs to be understood if the challenge to restore Peterborough Cathedral is to be fully appreciated. At the time of the fire, the Cathedral had just entered the second phase of a lengthy endeavour to put it on a more secure financial footing. During the mid 1990s it had become clear to me that a serious effort needed to be made to deal with some significant repair and restoration requirements concerning the Cathedral building itself and other properties within the Precincts. The Dean and Chapter were never going to be able to tackle projects of such size and cost while the Cathedral remained in such a parlous financial position. It was also clear that unless a substantial endowment could be established, to help fund the choirs and the music of the Cathedral, this very important element of the life of the Cathedral was in danger.

The front page of *The Peterborough Evening Telegraph* launching the Emergency Appeal, on Saturday 24 November 2001

Just ten months before the fire we had celebrated the successful completion of an appeal to raise £7.3 million for the Cathedral. This appeal included just over £1,000,000 towards an endowment to support the music of the Cathedral. Thanks to the backing given to us by English Heritage, we had been able to embark on a five-year plan to restore the Nave Ceiling. This was started in 1996 and would cost £1.6 million. It was a huge undertaking involving scaffolding in the Nave and the employment of skilled and dedicated restorers. At the time of the fire we had raised all the money needed to complete the ceiling restoration, and the work itself had made excellent progress. The scaffolders were about to move the scaffolding along to complete the final phase at the westernmost end of the ceiling.

I remember well going up this scaffolding in order to inspect the ceiling and investigate the damage caused to it by the fire with Richard Lithgow of The Perry Lithgow Partnership. He cleaned a small section of the ceiling to ascertain the extent of the deposits that had been left by the fire. It was obvious, even to my unqualified eye, that the whole of the ceiling would have to be re-scaffolded and completely cleaned once again. The cleaning was a delicate operation: the dirt and deposits were removed by hand using a small piece of granular rubber. I could immediately see that it would take several years – yet more years of scaffolding!

Following the successful conclusion to the 1996 Appeal and the raising of the £7.3 million, we had begun to discuss ways and means of continuing to raise funds for the Cathedral so that we could avoid another major appeal ever again. The scheme, called The Company of St Peter, was established in September 2001. The fire on that November night, just two months later, threatened the future of this important enterprise. There is no doubt that the fire and the need to launch an emergency appeal for the restoration of the Cathedral were setbacks for The Company of St Peter and its strategy to raise funds. However, God was indeed looking after us and the work of the Cathedral. For, if we had stopped seeking to raise funds at the conclusion of the 1996 Appeal, and had closed down the fund-raising office, we would not have been in a position to launch an emergency appeal as quickly and effectively as we did. It is difficult to imagine how we would have coped with this additional task without the experience and involvement of our fund-raising personnel from Compton International.

The day after the fire we launched an Emergency Appeal for about £1.5 million. As a result of the massive exposure of our problems in the media, there was a dramatic reaction from the general public to the need for financial help. I knew by then that we were well insured and that our insurers, The Ecclesiastical Insurance Group, would not let us down. Nevertheless, I also knew that we needed additional funds if we were to turn what appeared to be a disaster into something that would eventually prove to be a positive experience and of lasting benefit.

The CD that was sent out with a letter which raised £35,000 for the Emergency Appeal

The response of the general public was amazing. People poured into the Cathedral to express their sympathy and contribute to our Appeal. Some gifts were large, some very small, but each was a sincere expression of concern and support for the Cathedral. In the first year following the fire we received more individual gifts than in all the four years of the 1996 Appeal. Wherever possible, each person was thanked and placed on a mailing list so that we could keep them informed by newsletter of the progress of both the appeal and the restoration work. This same group responded magnificently when we decided to draw the Emergency Appeal to a close at the end of December 2004. We wrote to each person who had contributed to the Appeal with a final plea to help us reach the target we now felt was required. A small CD was included with the letter, containing some footage from the video of the fire made by the fire brigade, information on the Emergency Appeal and how we had used the funds, and a final appeal to people to be generous once again. The CD and letter produced an amazing £35,000.

The people of Peterborough, the Diocese and beyond, were extraordinarily generous. This book is both a 'thank you' to all those who contributed to the restoration of the Cathedral and a record of their generosity. It is a book which I hope these people will cherish and show their friends, family and, in particular, their grandchildren – to show how they helped restore the Cathedral to its former glory. Thanks to the support of such people, Peterborough, the Diocese and the nation still have a most amazing Cathedral. It is now in better condition and state of preservation than it has been for centuries. Thanks to their help we now have what must be the cleanest Cathedral in Christendom.

Of course, the £1.25 million that was raised for the restoration of the Cathedral following the fire and the £7.3 million that had been raised in the 1996 Appeal were contributed not only by a great number of small donors, important and vital as these were, but also because a small group of individuals, charities and foundations made the decision to support us in our hour of need. There are individuals behind such organizations whom this book is also designed to thank. Without such people, charities and grantmaking bodies, what we have achieved would not have been possible. I hope and pray that God will raise up others with such vision, wisdom and generosity, to play a similar role if such a need, as ours in November 2001, should ever arise again.

3 / Restoring the Nave Ceiling

One of the most challenging, skilled and yet tedious tasks following the fire was that of the cleaning of the Nave Ceiling. The ceiling structure and original paint scheme dates from the mid thirteenth century, but it was partially repainted in 1835. The story of the restoration of this magnificent piece of medieval art – for which Peterborough Cathedral is famous – has to be a major focus of this account. In the pages following the present account, Professor Paul Binski describes the artistry and iconography of the ceiling so that its importance, and the reason for our concern for its restoration, can be better appreciated.

The story of the recent, post-fire, restoration of the Nave Ceiling has to be appreciated in its context. Probably the most comprehensive restoration of the

The Cathedral architect Julian Limentani standing between Mary Bunker and the consultant conservator Gillian Lewis; with his back turned is Richard Lithgow of The Perry Lithgow Partnership.

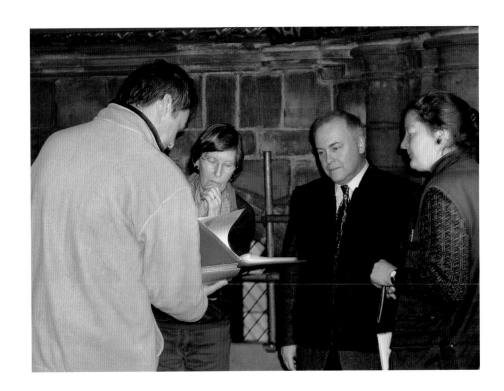

ceiling since its erection and painting in the 1200s had been started in 1994, when Gillian Lewis was appointed as Consultant Conservator to assist the Cathedral's architect, Julian Limentani, to investigate and make a proposal for the ceiling restoration. A platform was erected at the east end of the Nave, under the ceiling, to aid investigation and to facilitate the installation of equipment to monitor environmental conditions in the Nave, both at ceiling level and in the roof space above. It was these sensors registering temperature and humidity that, in 2001, were to record the effects of the fire and show just how close we came to a major catastrophe.

The platform created by the scaffolding enabled us all to see that a major work of restoration was urgently needed if the integrity of the ceiling was to be preserved. Even an untrained eye could appreciate the poor state of the paintwork and of the fixings that were holding the individual boards to the supporting structure. Indeed, the view from this platform looking east was a frightening sight: a sea of medieval wrought-iron nails hung perilously from the wooden planks. Either the nails would have to be removed or else a net would have to be hung along the length of the Nave to catch any if they fell. A mobile hydraulic hoist was hired and all the loose nails removed. This machine also gave our architect and Gillian Lewis an opportunity to examine the ceiling at close quarters. There was clearly need for a detailed survey of the ceiling, to assess the state of the fixings of the ceiling boards and the supporting structure. The attempt to restore the ceiling and its fixings in the 1830s had made it very rigid and incapable of flexing with the changing temperatures and humidity in the Nave. While some of the supporting bolts were not taking any of the weight of the structure, others were having to carry much more than their share – not a satisfactory state of affairs. Clearly restoration of the ceiling was urgent. However, before the appropriate way forward could be agreed upon, further research into the state of the ceiling was necessary.

The research conducted was, to quote an article in *The Architects' Journal*, a "sophisticated and meticulous programme". The ceiling at Peterborough was worthy of such careful attention. Sixty-two metres long, eleven metres wide, canted on each side and twenty-five metres off the ground, it is constructed in a similar way to a clinker-built boat with overlapping boards (see diagram in *The Architects' Journal* on page 30).

This careful research into the state of the ceiling was helped considerably by support from English Heritage, who allowed us the use of their sophisticated metric survey techniques. These were to provide a large amount of high-resolution and accurate data that formed the base information for our architect and the team of conservators. I am most grateful to English Heritage for

The thirteenth-
century painted
Nave Ceiling,
looking west

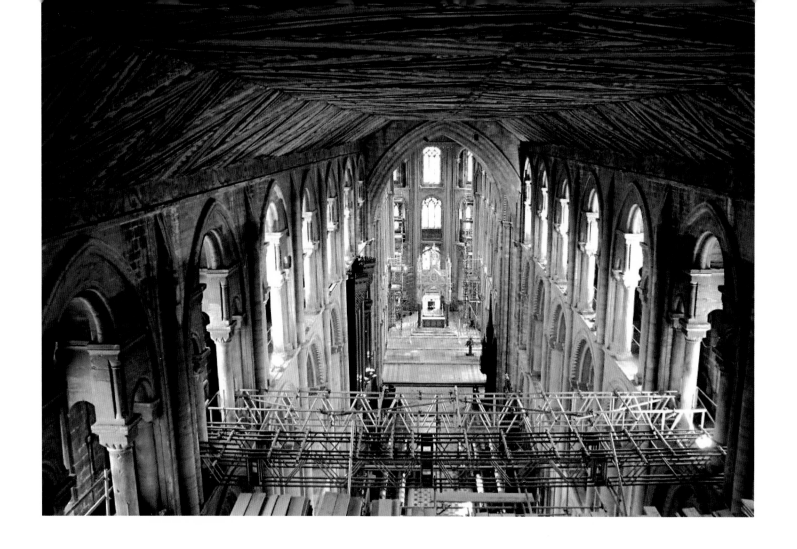

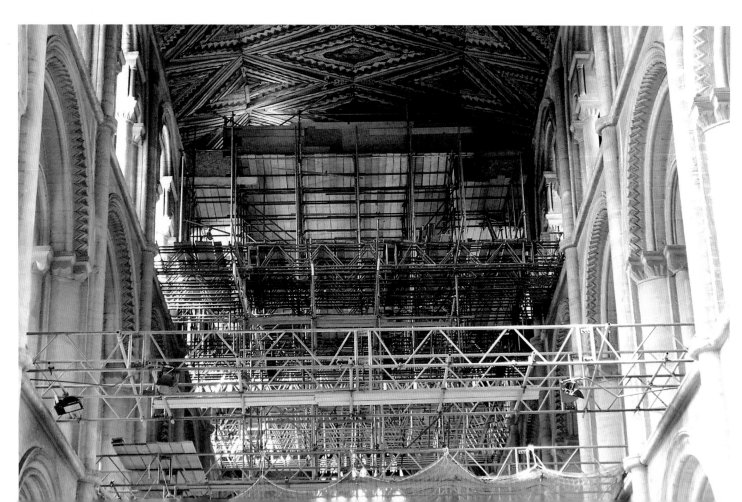

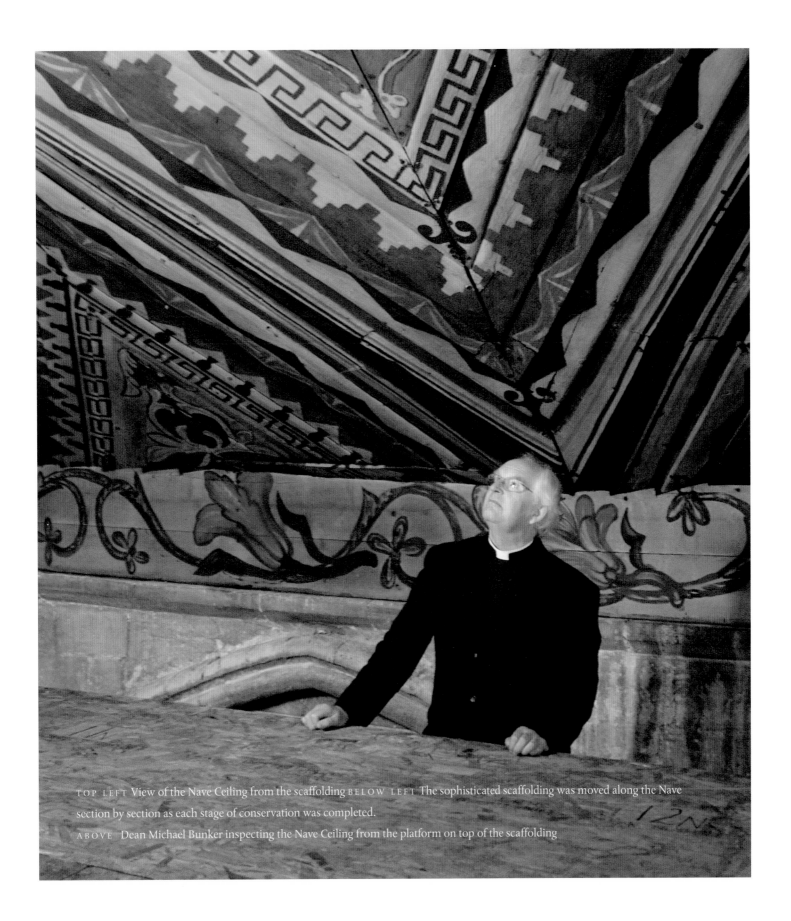

TOP LEFT View of the Nave Ceiling from the scaffolding BELOW LEFT The sophisticated scaffolding was moved along the Nave section by section as each stage of conservation was completed.

ABOVE Dean Michael Bunker inspecting the Nave Ceiling from the platform on top of the scaffolding

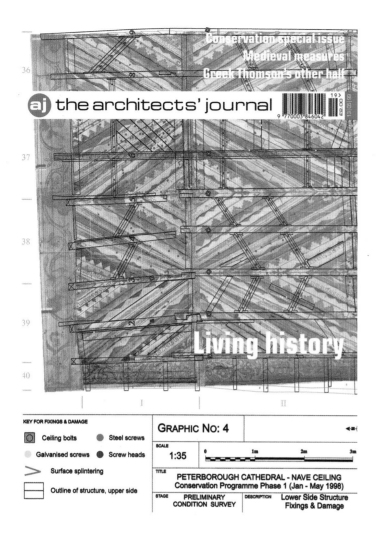

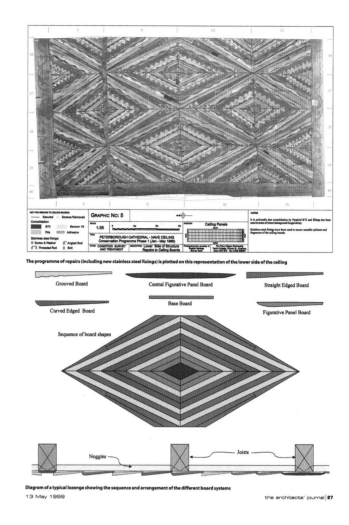

ABOVE Illustrations of the structure of the Nave Ceiling from *The Architects' Journal*, December 2003

ABOVE RIGHT Richard Lithgow, on the day after the fire, inspecting the extent of the soot deposit on the Nave Ceiling, which had only recently been cleaned

BELOW RIGHT A typical arrangement for cleaning the Nave Ceiling from a platform on top of the scaffolding

allowing me to reprint here an article in their publication, 'Measured and Drawn', which describes the details of their surveying procedure (see pages 122–25). The information about the construction and condition of the ceiling that this piece of innovative research gave us was of enormous benefit as we began to embark on the conservation of the Nave Ceiling. It deserves wider recognition. Without this information, we would not have been able to restore the ceiling and preserve it, in the way we have, for future generations to enjoy and admire.

Further research, in the form of paint analysis, was carried out by Dr Helen Howard of the Conservation of Wall Paintings Department at the Courtauld Institute of Art, to identify the original pigments and technique used to decorate the ceiling. She also investigated some of the rather crude over-painting that was found in a number of places along the length of the ceiling. The nature of the paints used in the nineteenth-century intervention, and the considerable amount of flaking and powdering of the paint in the decorations, were to be a challenge to the conservators. Furthermore, there was extensive staining on the ceiling deco-

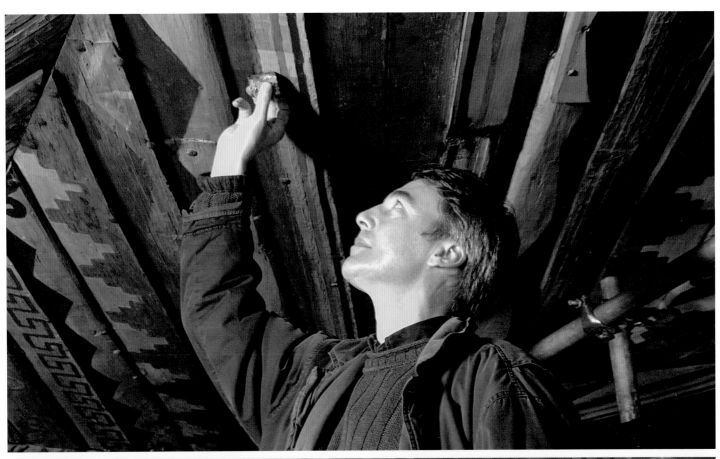
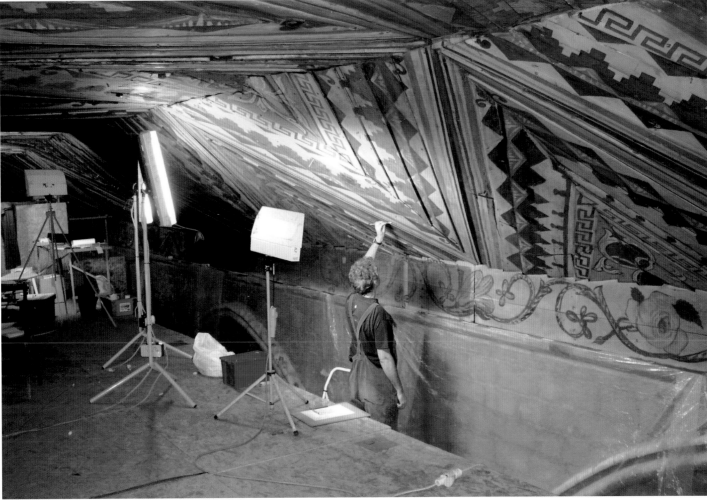

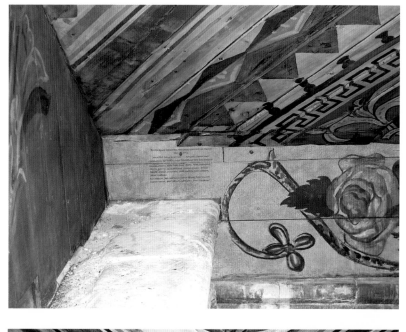

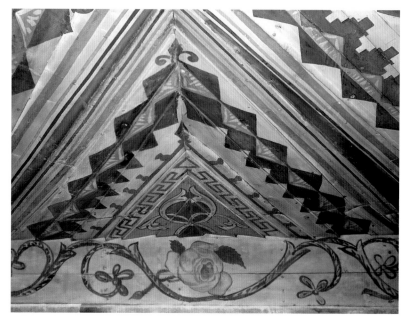

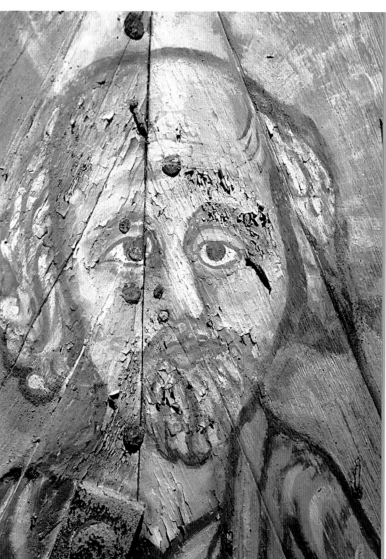

At the juncture of the Nave Ceiling and the wall the restoration team left a commemoration of their work (see detail overleaf)

One of the lozenges of which the ceiling is made up, after cleaning, where it meets the painted wooden 'ashlar' just above the wall

Detail of the ceiling painting of St Peter before the restoration

Detail illustrating the jointing of the planks

Damage caused in the 1920s by glue used to stick hessian on to the ceiling panels

Graffiti on a window through which the Deanery garden can be seen

ration that had to be removed. The damage had been caused by an attempt made in the 1920s to stabilize the structure of the ceiling; subsequently the glue that had been used to stick the hessian on to the upper side of the ceiling panels had seeped on to the painted side of the boards (see illustration middle left opposite).

The work of conserving the ceiling was a skilled task and the nature of the paint meant that a dry cleaning process had to be used. It was all done by hand using shaped pieces of Wishap™ (cakes of synthetic rubber granules that self-abrade when wiped across a surface) and brushes. In many places, the cleaning could not be tackled until the flaking paint was 'relaxed' and glued back in place. Of course, the fire meant that all the painstaking cleaning would eventually have to be done twice.

Along with the work of restoring the painted boards went the task of securing the support of the ceiling. As has already been mentioned, an earlier intervention, in 1835, using hessian and screws to secure the boards created a very rigid structure which was unable to move with the changing conditions within the Cathedral. Hugh Harrison and his team worked with great skill within the roof space and high up on scaffolding to secure the structure of the ceiling. Now the ceiling is properly supported through its entire length and breadth in what is a very fine piece of engineering.

PETERBOROUGH CATHEDRAL NAVE CEILING CONSERVATION PROJECT
1994 — 2003
ARCHITECT: JULIAN LIMENTANI ADVISER: GILLIAN LEWIS
CONSERVATORS: THE PERRY LITHGOW PARTNERSHIP WITH HUGH HARRISON

RICHARD LITHGOW, MARK PERRY, DAVID PERRY, PETER MARTINDALE, CRISTINA BERETTA, LOUISE BRADSHAW, CAROLINE BAINES, BIANCA MADDEN, NATALIA SEGGERMAN, GREG HOWARTH, SAŠA KOSINOVA, SARAH LIVERMORE.
HUGH HARRISON, BOB CHAPPELL, CAMERON STEWART, PETER FERGUSON, JONATHAN PORTER, BRETT WRIGHT, CLAIRE CULLY, STUART ANDERSON.

The record left on the ceiling by the team of conservators in 2003

A dendrochronological analysis of some of the oak timbers from the Cathedral brought to light some interesting information. The analysis was carried out by Cathy Groves and Ian Tyers from the Archaeology Research School at the University of Sheffield, and was eventually published for English Heritage. The research confirmed the accuracy of the accepted dating of the Cathedral's construction. A most surprising discovery to emerge from this research was that the trees from which the ceiling boards were cut came not from around Peterborough, nor even from this country, but from northern Germany. The boards used to create the north and south Transept Ceilings, on the other hand, were sourced from this country but were twenty or thirty years older (from around 1220). Why the Nave Ceiling boards were imported cannot be known for sure, but perhaps local straight-grained oak had run out.

One final discovery I must share is of all the graffiti left on the Nave Ceiling throughout the centuries, by those who wanted to leave their mark on the Cathedral. Perhaps most thought their secret would never be uncovered. The final illustration in this series is of the graffiti left by Richard Lithgow and Hugh Harrison's team of conservators, painted in the Nave Ceiling at the west end of the Cathedral (see above and preceding page). It is a small tribute to their skill and hard work in the restoration of this great Nave Ceiling.

4 / The Challenge of Cleaning

Michael Bunker inspecting the fire damage

Peering into the murky interior of the Cathedral on the night of the fire, I was struck by the thought that it would be impossible to use the place for worship for quite some time. The smoke from the burning plastic of the chairs had left not only a greasy, black, soot-like deposit over every surface, but also a horrible smell hung in the air. Surely ridding the Cathedral of this smoky odour would be just as challenging as removing the soot? I made plans for the regular early morning services to take place in the Deanery rather than the Cathedral. Future arrangements would be made after a period of reflection.

By the following day it had become clear that our Christian responsibility was to turn this attack on the Cathedral around and bring as much good out of the experience as possible. We would do all in our power not to allow this misfortune to thwart our concern for the worship and mission of the Cathedral, or to hinder the restoration programme that had begun in 1996.

More has been achieved than we ever thought possible at the time. People who knew the Cathedral before the fire are amazed at just how magnificent it now looks. It sparkles with new life. The co-ordinator of this great and urgent project was Julian Limentani, the Cathedral's architect. We were extremely fortunate to have an architect who had already worked in the Cathedral for a number of years, and thus knew the building intimately. He proved to be unflappable in the most testing of circumstances, ensuring that each project within the overall objective of restoration was efficiently and effectively managed.

Julian would be the first to acknowledge the very professional support given by the Cathedral's insurers, The Ecclesiastical Insurance Group. The day after the fire, I received a supportive visit from one of the Group's Directors, John Coates. The visit was quickly followed by the arrival of a cheque, for £50,000, to pay for the initial clean-up and to help deal with immediate matters. Throughout

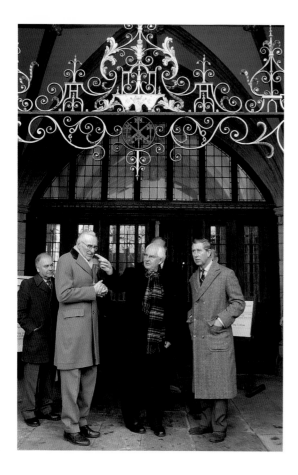

Meeting at the West Door (from left to right) Julian Limentani, the Cathedral architect; Sir Stephen Hastings, Chairman of the Peterborough Cathedral Development and Preservation Trust and Chairman of the Appeal; Dean Michael Bunker; and His Royal Highness the Prince of Wales

the restoration, our insurers lived up to their reputation as being top of their field.

Two days after the fire, a team of people came in to clean just enough chairs to use in our Sunday morning worship. As the Cathedral organ was out of action, two organists played the grand piano instead. These simple but important details seemed to indicate to the general public and to those who attended our main Eucharist on that first Sunday that there was no panic in the camp. Immediate action had been taken which gave the impression, at least, that we were on top of everything. We were greatly encouraged by the support and sympathy of the Duke of Gloucester, who came to visit us with the Duchess on the Sunday and on a number of subsequent occasions. His Royal Highness the Prince of Wales, who had previously visited the Cathedral to see the work in progress on the Nave ceiling, sent a kind message:

I was greatly distressed to learn of the fire in Peterborough Cathedral last night. I hope and pray that the damage caused by the fire will not be as extensive as everyone must have feared when they first heard this news. But I can imagine the anguish which you and all those who love the Cathedral must be feeling, particularly after the wonderful programme of restoration which has so nearly been completed. You are all much in my thoughts and prayers at this time.

Charles
Prince of Wales

Our final achievement could never have been realised without the contribution of the experienced fund-raising office. Because processes to raise the additional funds were already in place, we were able to make the most of all that this new and unexpected chance to restore the Cathedral further afforded us. Already under the belt of the fund-raising team was the successful completion of numerous projects – the restoration of the Nave Ceiling; the Western Range Project, which included the refurbishment of twelve Georgian flats and the creation of a Tourist Information Centre in the reclaimed vaults; the renovation of a number of historic buildings to create a café, and a book and gift shop; the restoration of numerous figures and the parapets on the New Building at the eastern end of the Cathedral; the repair of the tesserae paving between the Choir Stalls; and a whole host of smaller but archaeologically sensitive projects within the Precincts.

When the cleaners from Reclaim first arrived, the task ahead must have looked daunting. To provide enough chairs to last us for the next few weeks would mean cleaning over a thousand, as Advent Sunday was fast approaching. With Christmas

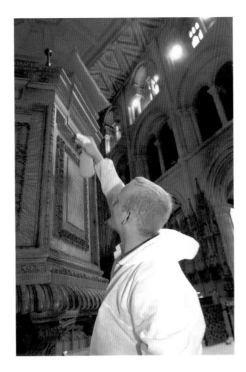

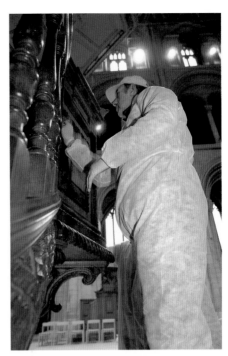

The Reclaim team cleaning the pulpit

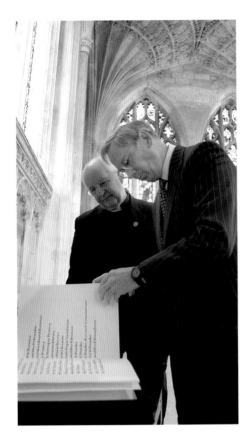

The Duke of Gloucester with Dean Michael Bunker on the occasion of the unveiling of the plaque listing donors to the Appeal

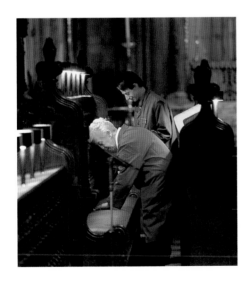

Sue Horsley, the Cathedral cleaner, and Les Featherstone, the Cathedral gardener, cleaning the choir stalls

only a month away, hundreds more were needed. It was an awesome sight to see the army of workers toiling so feverishly each day. The floors, walls, and columns inside the building were black and grimy, dirtying any hand that touched them and spoiling clothes that brushed against them. It was decided, therefore, that a basic clean of all the walls, initially only up to head height, was quickly needed. We made the North Transept and the easternmost end of the Cathedral, behind the High Altar, out of bounds in order to create some storage and working areas.

Another new presence on the first day was that of machines that were brought in to filter the air, to remove the smell and, indeed, the taste of the fire and burnt plastic. Thankfully, they were fairly quiet as they sucked and filtered, but they had to remain in place for a surprisingly long time, the last of them leaving the Cathedral only in 2003.

Getting the Cathedral clean enough to function was swiftly and successfully achieved, but fully erasing the effects of the fire took a lot more time, energy and commitment. As the photographs show, it was to take a huge variety of skills, experience and equipment, and was to be an exceedingly labour-intensive task that included brushing, vacuuming, wiping and rubbing. Of course, it was not only the grime produced by the fire that was removed during this process, but also the dust and dirt of the ages. Thanks to all the hard labour, the Cathedral is now as clean as it was when it was first built.

To clean a building of the size and complexity of our Cathedral was inevitably going to involve a huge amount of scaffolding and equipment. The task was made

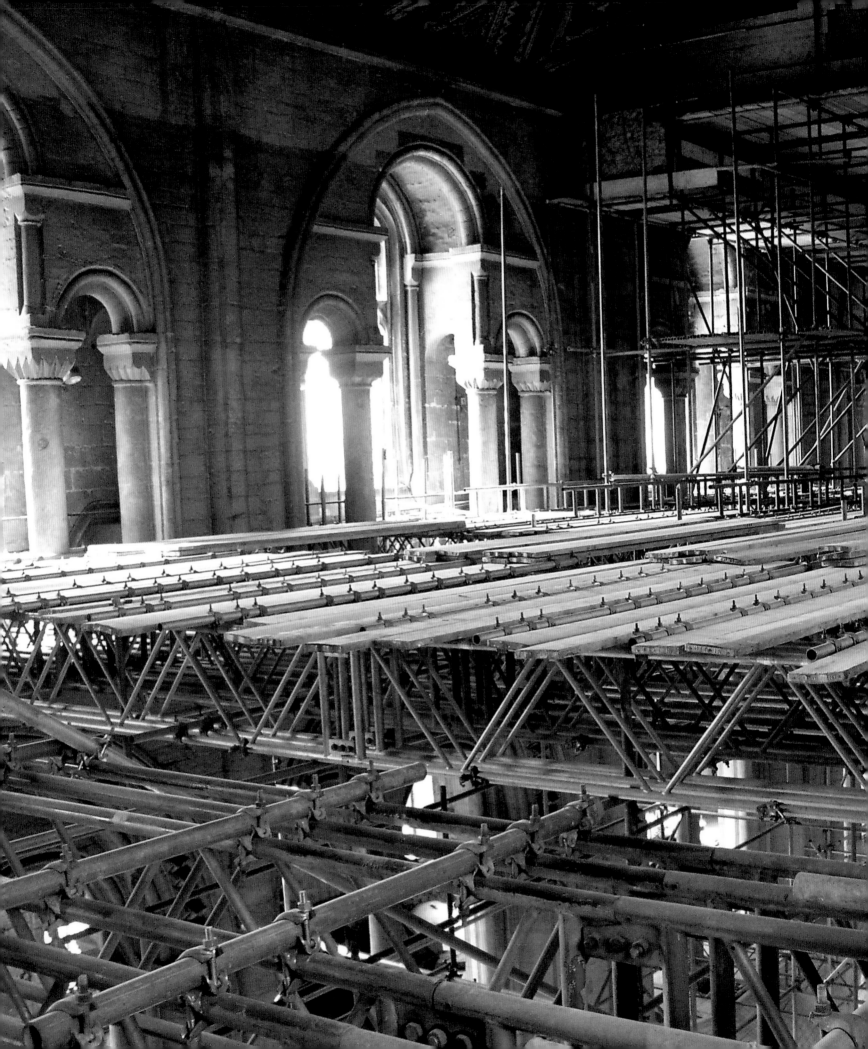

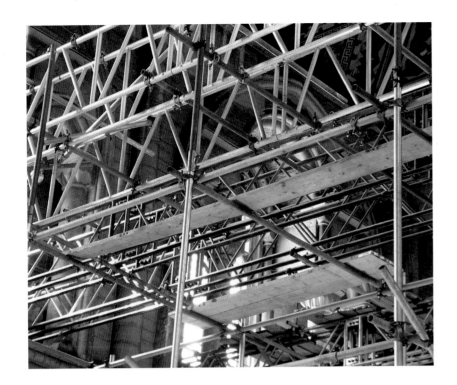
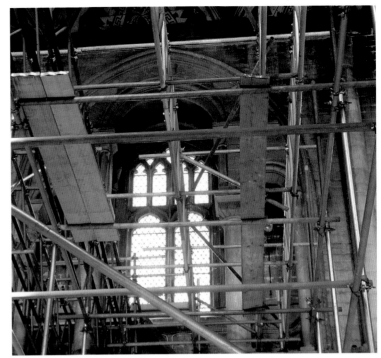
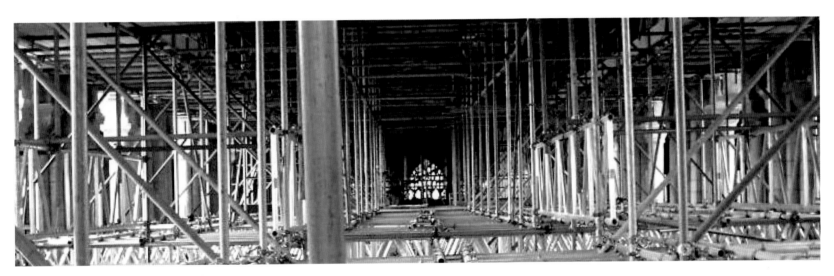

Two hundred tons of scaffolding filled the Cathedral during the restoration.

all the more demanding by the fact that this was an historic building which housed some important artefacts. The restoration of the Nave Ceiling was the most demanding task and involved tons of scaffolding being erected throughout the Cathedral. Scaffolding, coming in, going out, erected and removed, became a feature of Cathedral life for a number of years. It certainly was an eyesore, spoiling the vista as one entered through the West Door. However, the scaffolding was to become a special feature of people's visit: it was a common sight to see visitors sitting in the Nave peering up at the scaffolders as they went about their work. I am pleased that this book can illustrate the efforts that went on above people's heads and out of sight.

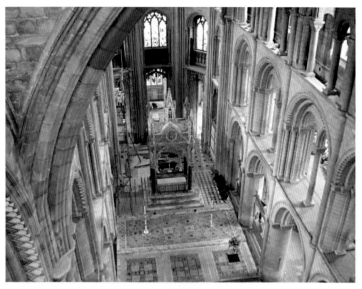

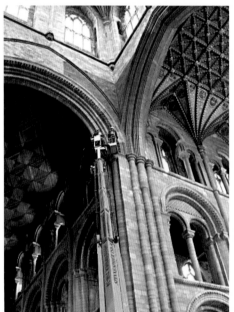

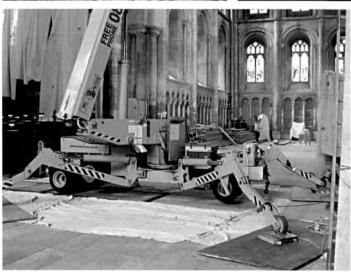

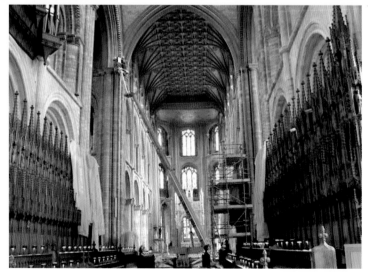

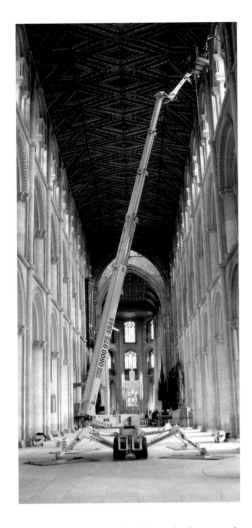

First, there was the general cleaning – masses of it. Walls, columns, windows and stairwells – every surface had to be cleaned, even those hidden from sight at the clerestory and triforium levels. Much of the cleaning required an hydraulic hoist and there were some places that neither scaffolding nor hoist could reach . The smoke and greasy deposits extended everywhere – even to the voids between the upper side of the ceilings and the roof. Here, other skills had to be utilized – skills one would not expect to see applied in a cathedral. A team from Vertical Technology suspended themselves on ropes from the roof trusses and hung in mid air to clean those parts of the building that others could not reach. They were rather an eerie sight, suspended in the darkness of the roof space with only the light on their safety helmets signifying their presence. The team did a great job in the most difficult of working environments.

Another difficult area was to be found in the vaults at the west end, which are extremely high and were very dirty indeed. It was amazing to see the vaulting and stone carving at such close quarters, detail which previously could have been seen only through binoculars. The cleaning in this area uncovered a wall-

LEFT Views from and of the spider hoist used in the work on the Central Tower

ABOVE The spider hoist reaches the Nave Ceiling

RIGHT A member of the Vertical Technology team suspended from the roof trusses

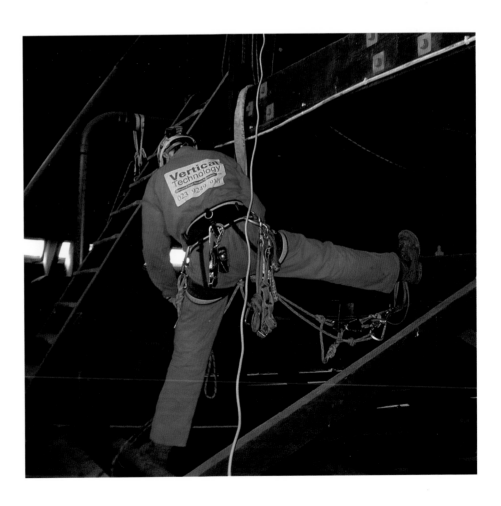

ABOVE Thirteenth-century
wall painting in the South
Aisle

RIGHT Scaffolding in the
Choir

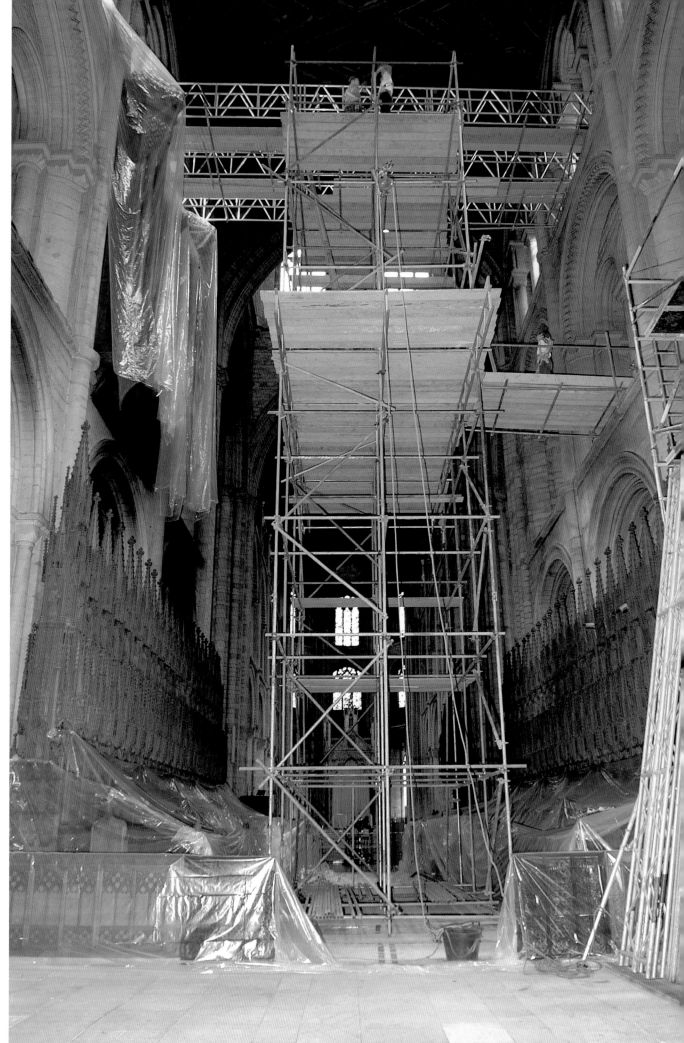

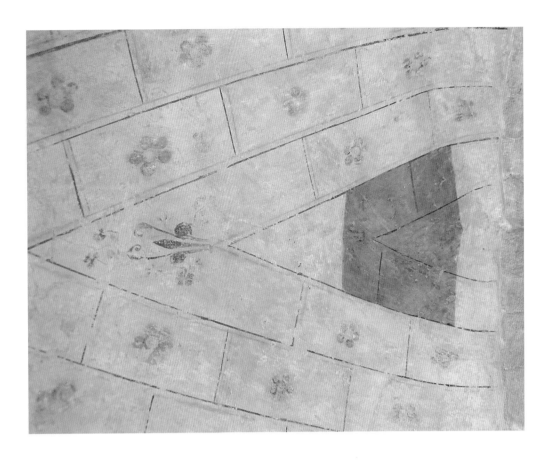

ABOVE AND RIGHT Thirteenth-century wall painting in the South Aisle. An uncleaned part shows much darker.

painting that may not have been seen for centuries. Once discovered, it had to be treated with great care, like all the other remnants of wall paintings that are scattered throughout the building. Its recovery demanded a great deal of patience and skill.

The cleaning and restoration process threw up some very interesting and varied challenges which called for an assortment of skills and expertise. Listed below are but a few further examples: the High Altar is one of the principal features within the Cathedral, but, though undoubtedly eye-catching, it is not one that every visitor appreciates. It was an 1890s addition to the Cathedral and is based on the altar in Santa Maria in Cosmedin, Rome. When J.L. Pearson, the Cathedral architect at the time, had to repair the Central Tower, he took the opportunity to remodel the Choir, Sanctuary areas and High Altar as well. The altar is made of marble and alabaster, the latter of which was particularly vulnerable to spoiling by the sooty deposits left by the fire. Within the first month of the restoration process the High Altar was scaffolded to allow the delicate and careful cleaning work to begin. Once completed, it was then encased in bubble wrap and the scaffolding removed – an ugly appearance that it maintained for three

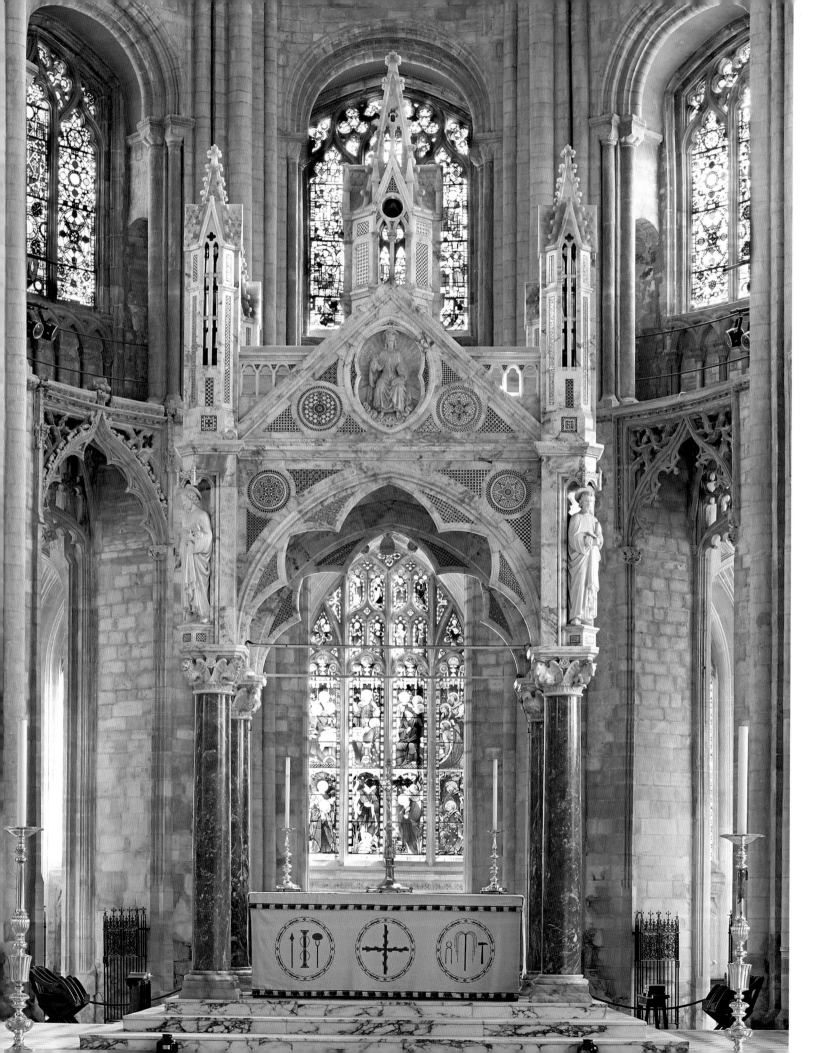

Painstaking cleaning of the Choir Stalls with a small brush by conservators from Tankerdale

Cleaning the nineteenth-century stained glass window in the Chapel of St Oswold in the South Transept, designed by Burlison and Grylls

OPPOSITE The Ciborium over the High Altar, designed by J.L. Pearson in the 1890s

whole years. Its eventual removal signified, to us all, the emergence of a new era for the Cathedral.

The Choir Stalls, along with the Pulpit and Bishop's Throne, presented us with a challenge of a different order. Unlike the High Altar, this area was left alone until the end of the cleaning process for fear that it would quickly become spoilt again by the dust that was disturbed during the clean-up. It was impossible for us to cocoon completely and protect the Choir Stalls for the duration of the cleaning process, so we were forced to look at this sooty and dirty feature until the last few months of the restoration, when it was finally covered in scaffolding and the sensitive cleaning began. Delicate and fragile, the carved features of the stalls required the use of small brushes and specially adapted suction equipment.

All the windows throughout the Cathedral had to be cleaned. Some required little more than is done in any home, but there were numerous windows that, because of their position, fragility and age, demanded a different approach. The effect of this work, coupled with the cleaning of all the masonry within the building, has meant that, when the sun shines through these windows, those of us who have known the Cathedral for a number of years feel as if we have been transported back to the time when it was first built.

It is perhaps often forgotten that cathedrals consist not only of hard surfaces – stone, glass, wood and metal – but also of soft furnishings and fittings; Peterborough is no exception. Robes, frontals, banners, kneelers and more – all had to be cleaned. Most could be cleaned *in situ* but some, such as the two large tapestries that hung in the Apse Chapel, had to be sent away for specialist attention.

During the long cleaning process, I often thought to myself that my work on this task was similar to that of my previous responsibility, some years ago, of

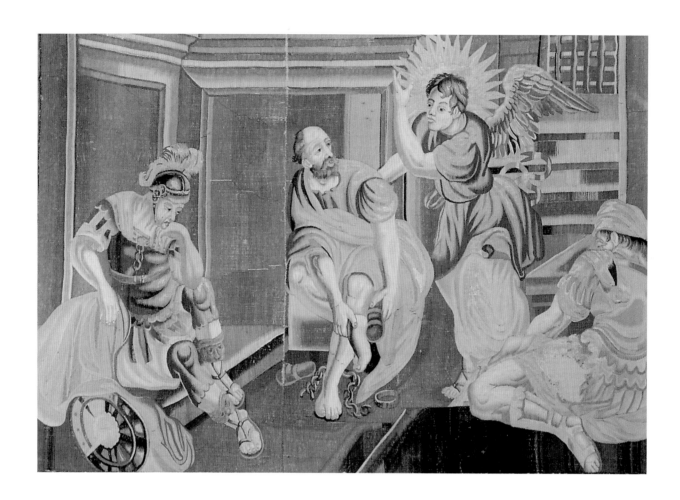

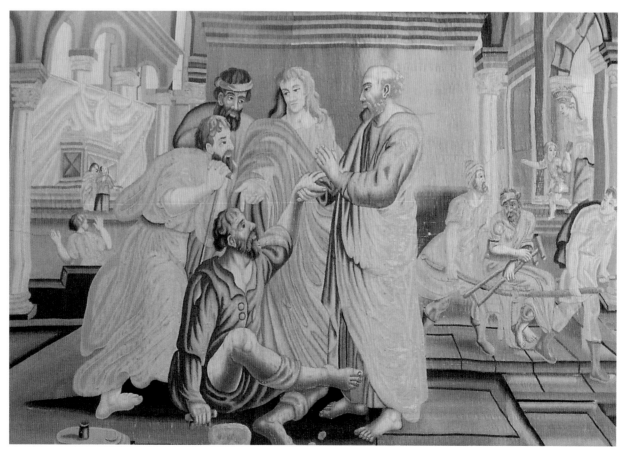

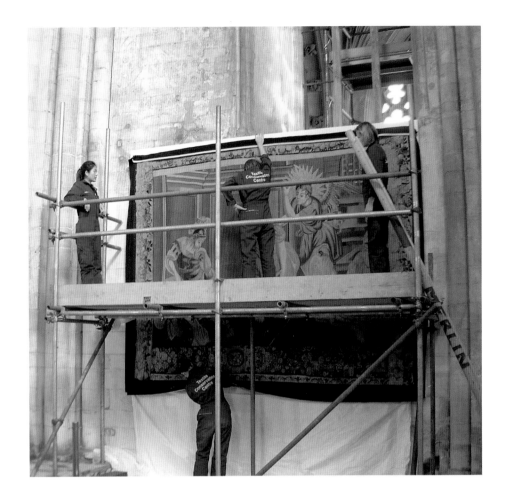

seeking to rebuild the congregation at St James's Church in Muswell Hill, North
London. When I first arrived there, the congregation had dwindled to a very small
number, so I set about drawing together a range of committed people with the
faith and vision to work for the restoration of that Christian community. It was
a wonderful period of my life, and now the church can boast one of the largest
congregations in the capital. It was a great privilege to be involved at the early stage
of that development, just as it was to help in the restoration of Peterborough
Cathedral. An even greater task is left to my successor as Dean – to use this mar-
vellous building and to make the Cathedral what it should be – a constant source
of inspiration both for those who visit the building and experience its worship
and ministry and for those who hear of its creative activities and of its having
become a centre of spiritual renewal.

5 / Stone, Vaults and Bosses

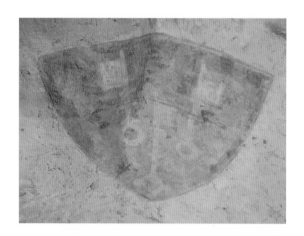

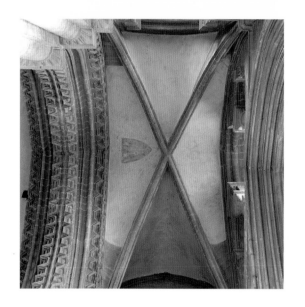

The rediscovered red shield in the Nave Vaulting, probably dating from *c.* 1230

The red shield is clearly visible from the floor of the Nave

The work of restoration produced many surprises. The process generated a mass of information about various aspects of the Cathedral which had never previously been unearthed. The sheer volume of this data is such that I can give but a few examples. Everyone expected the restoration of the Nave Ceiling to be the most interesting and greatest challenge, and so it proved. However, from July 2002, when we turned our attention elsewhere, we were to find many further unexpected revelations.

Nave vaulting

Approaching the end of the restoration, as we started to clean the great vaulting at the west end of the Nave, an interesting discovery was made. As The Perry Lithgow Partnership team removed the veil of sooty deposits and centuries of dust from the north side of the vaulting, the faint outline of a red shield began to emerge (see illustrations left). The shield was subsequently so skilfully uncovered and cleaned that now it is visible even from the floor of the Nave, some hundred feet below. It seems likely that this painting was created around 1230, but it has probably not been seen by visitors for many centuries.

The Nave Aisles

I was particularly concerned about the cleaning of the North Nave Aisle. The seat of the fire was in the eastern end of this area, behind the Choir, and it was here that the fire did some of its worst damage. At the time, it seemed that it might not be possible to remove all the dirt and soot here. I feared that the fire might leave the Cathedral permanently scarred, either because it would be impossible to remove all the soot, or because the cleaning would necessarily be so vigorous that the process itself would cause damage. I need not have feared. The area has been so well dealt with that I am frequently asked by visitors, "Where did the fire happen?" This success was thanks to the use of a very modern technology – the application of a special latex substance, sprayed on to the ceiling, left to harden for twelve to twenty-four hours, and then carefully removed. As

Cleaning the memorial to Robert Scarlett, the grave digger who buried Mary Queen of Scots and Katharine of Aragon, and who himself is buried in the Cathedral

Cleaning the west wall (the memorial to Robert Scarlett is above the pointed arches to the right of the door)

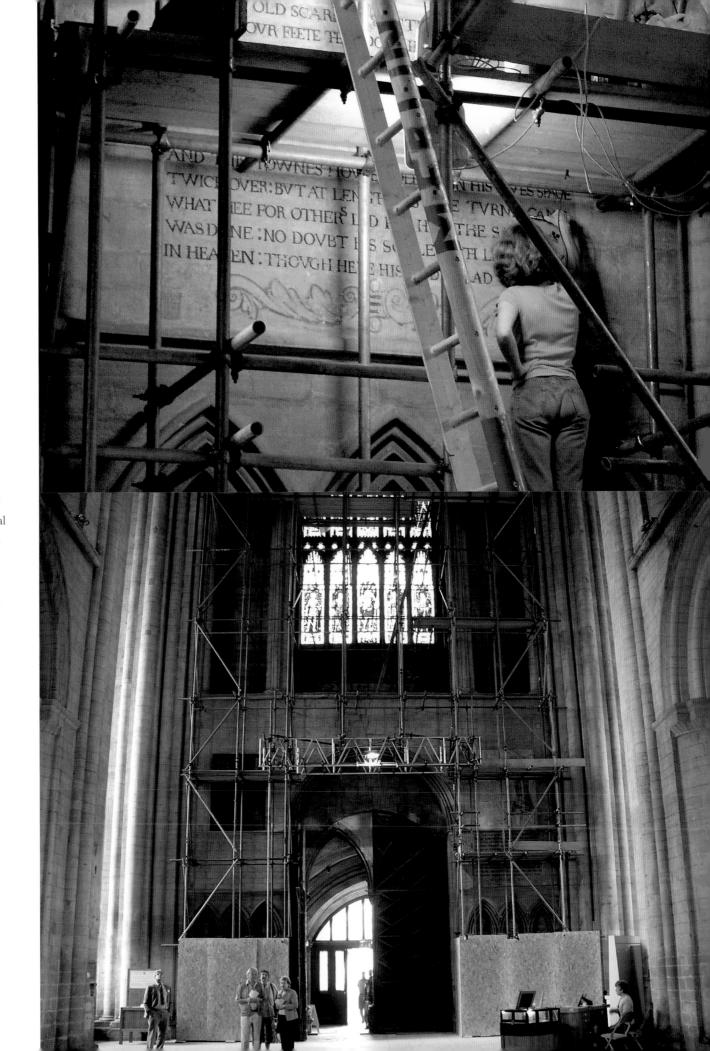

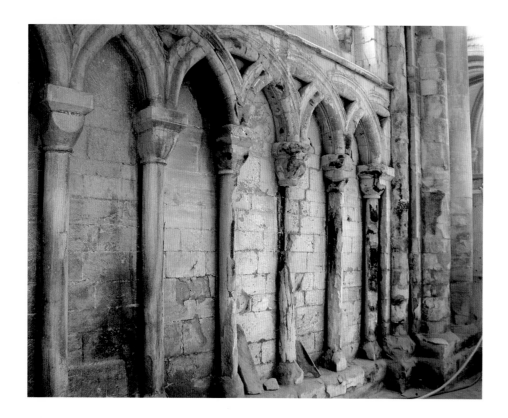

this was done, the soot and the grime of the ages was literally sucked out of the walls and ceilings to reveal bright, clean stonework, looking much as it must have done when first put in place by the original masons (see illustrations right).

The south side had other secrets to reveal. As we knew that the vaulting along the South Nave Aisle contained some wall painting, special care was taken in the restoration process. As it turned out, the meticulous and patient work revealed many unknown areas of painting, which are of such quality and age that they will deserve special mention in any future guided tour or publications about the Cathedral (see illustrations overleaf)

The Central Tower

Getting within reach of the Central Tower ceiling was an amazing experience. The detail of the decorations, the artistry and scale of the bosses, will never be forgotten. Most people have only been able to see the Tower ceiling from the floor with the aid of binoculars. A few have been able to look from clerestory level. For me to be able to get so close, to be within touching distance, was truly inspiring. The work had not been seen by anyone at this proximity since J.L. Pearson reconstructed the Central Tower in the 1880s. The Tower had been one of the most

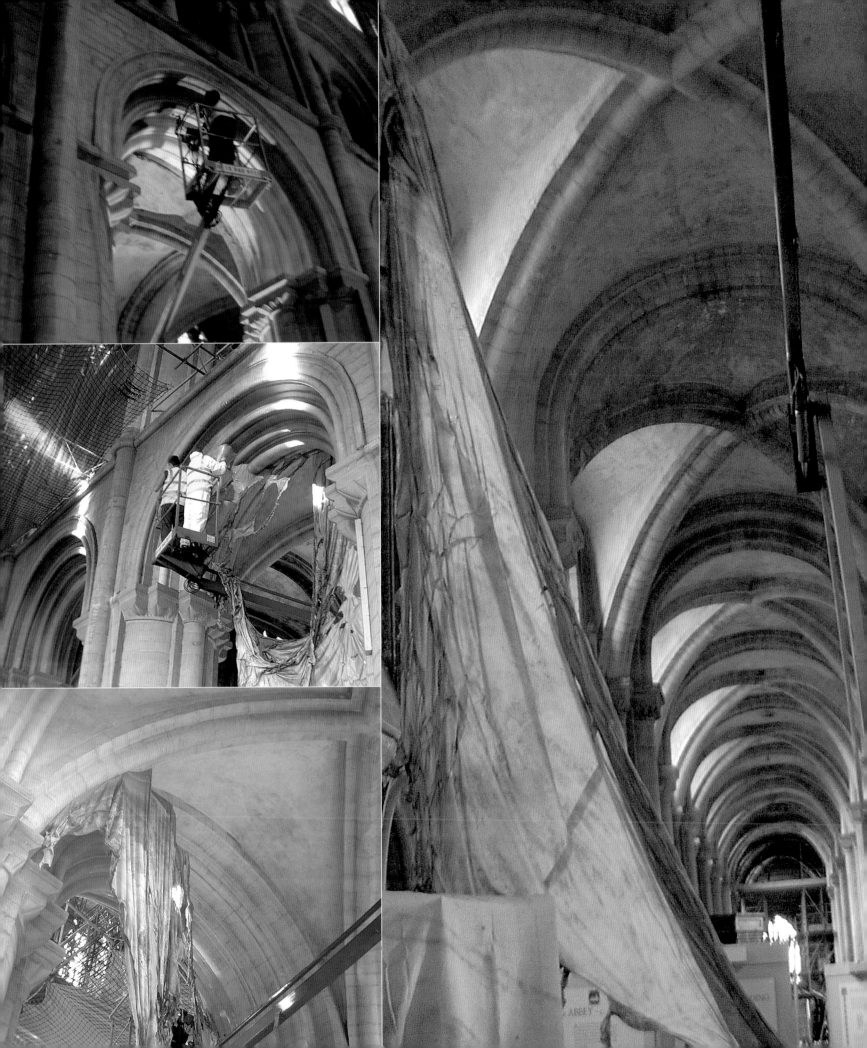

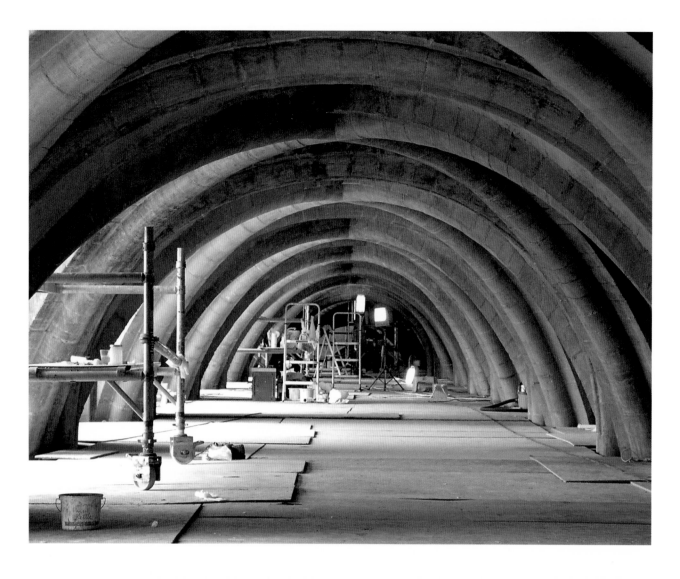

LEFT
Vaulting of the South Nave Aisle undergoing restoration

BELOW
Painted vaulting from the South Nave Aisle. Latex cleaning could not be used here (as it was in the North Nave Aisle) because it might have damaged the paint on the stone and plaster.

OPPOSITE
The front cover of *The Illustrated London News* of 27 January 1883, when work started on the taking down and rebuilding of the Central Tower

OVERLEAF
The Central Tower ceiling seen from directly below

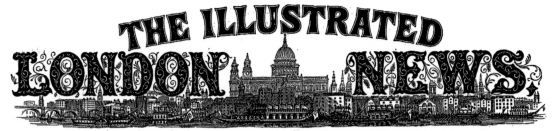

THE ILLUSTRATED LONDON NEWS

REGISTERED AT THE GENERAL POST-OFFICE FOR TRANSMISSION ABROAD.

No. 2284.—VOL. LXXXII.　　SATURDAY, JANUARY 27, 1883.　　WITH TWO SUPPLEMENTS } SIXPENCE. BY POST, 6½d.

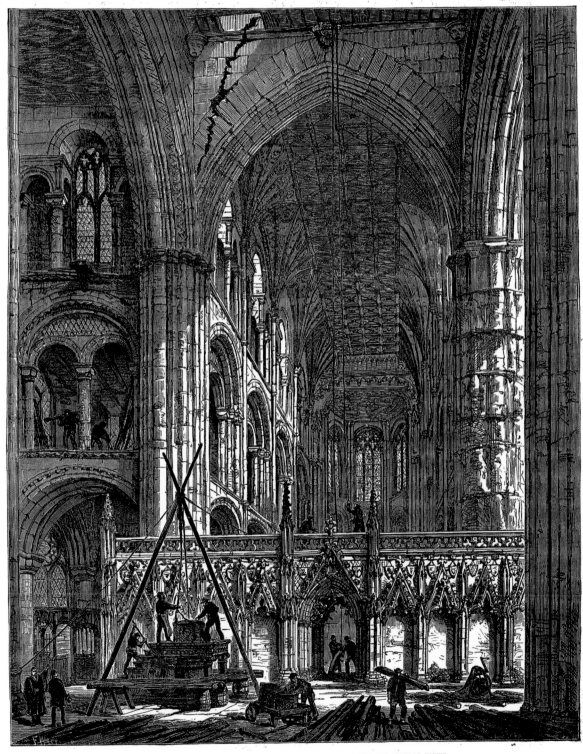

PETERBOROUGH CATHEDRAL: PREPARATIONS FOR PULLING DOWN THE CENTRAL TOWER.

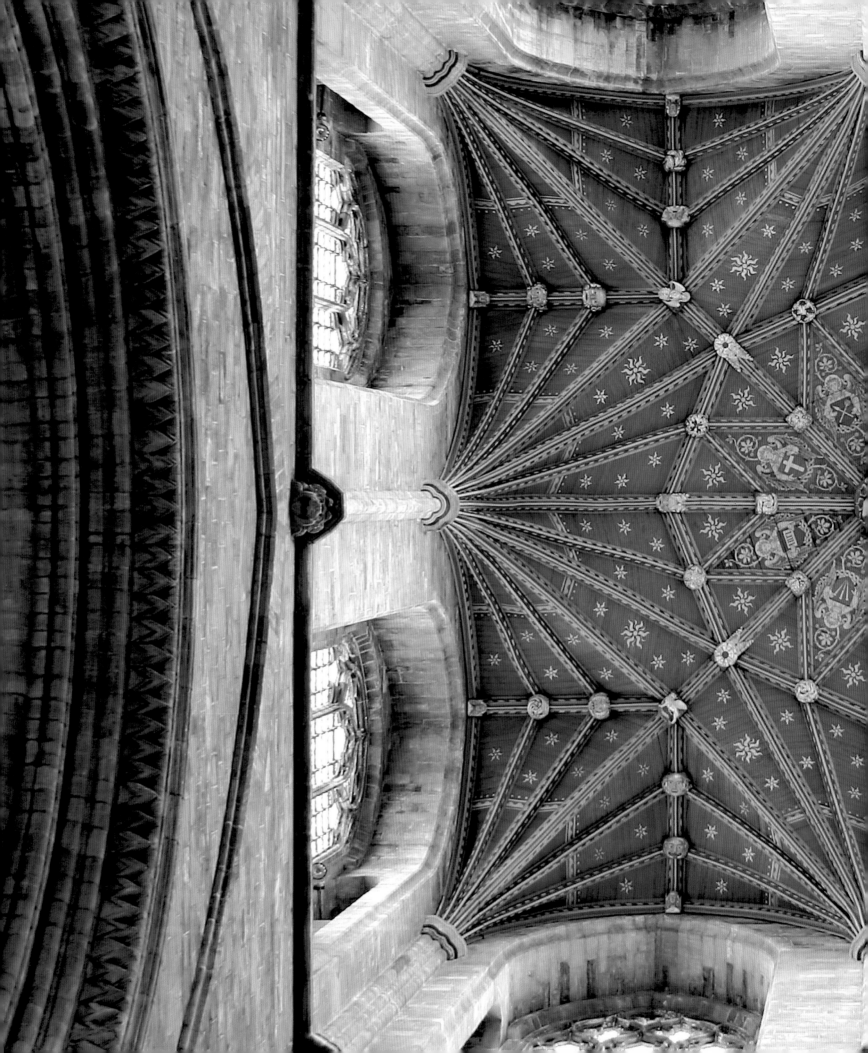

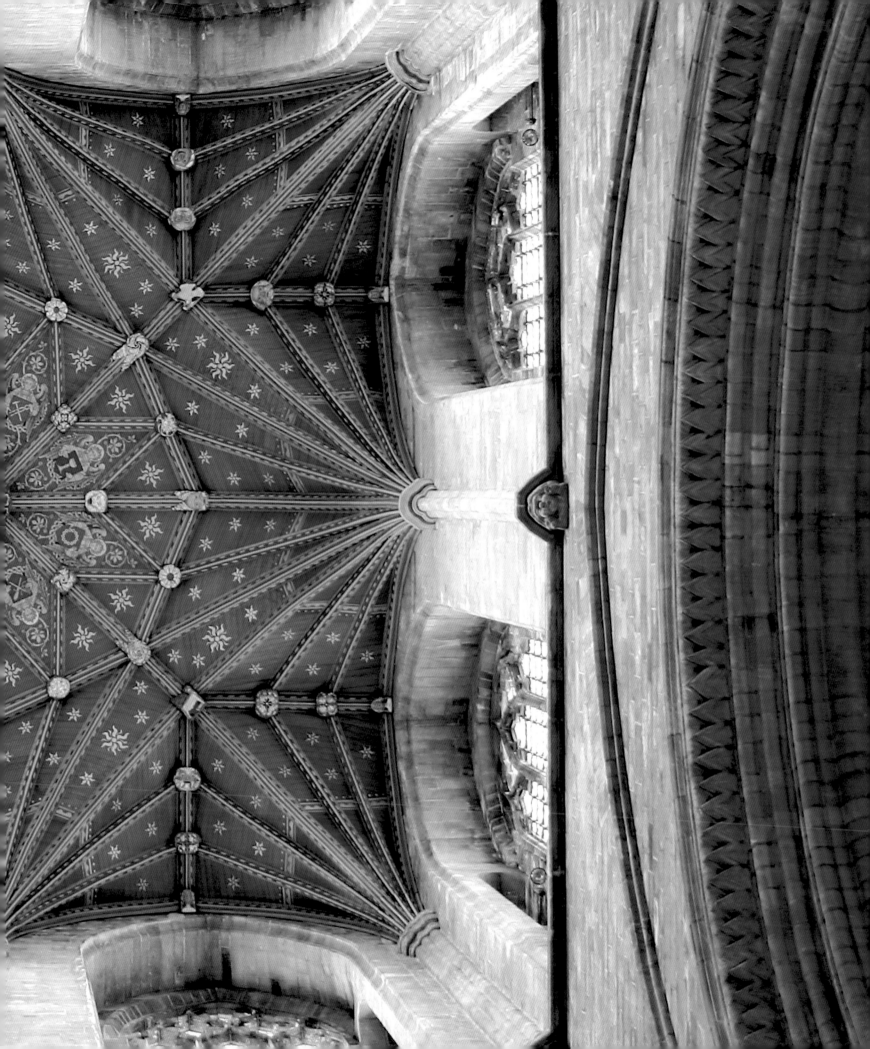

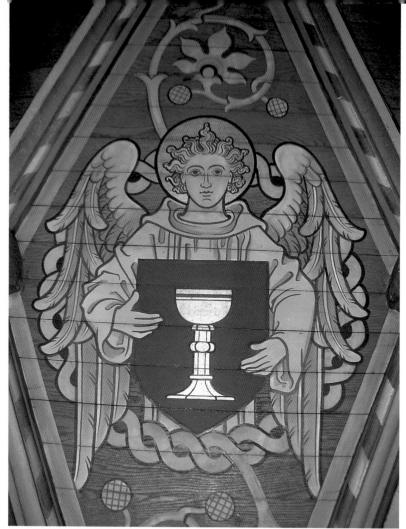

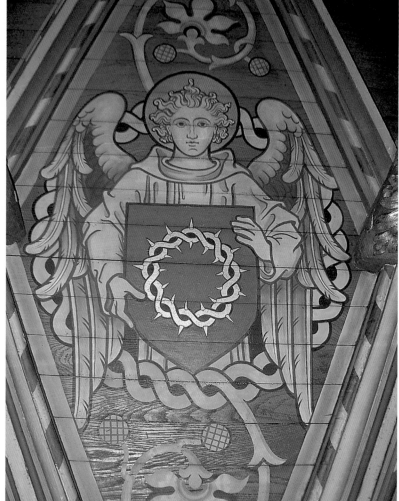

ABOVE Detail from the Central Tower: the original boss of God the Father, which was repainted in the nineteenth century

RIGHT Nineteenth-century painted angels, on the Central Tower ceiling, carrying Symbols of the Passion

precarious parts of the Cathedral owing to the unsatisfactory manner in which it was first built. Though it had been rebuilt in the mid-fourteenth century, it was only fully secured in the 1880s by Pearson with the aid of his brilliant Clerk of Works, John Irvine. The whole of the Tower was taken down, stone by stone, and then re-erected on deeper foundations and with a more substantial core inside the columns. This essential work on the tower, however, had intruded into the structure of the Nave Ceiling. It had also impacted on the Transept, Presbytery and Apse Ceilings, which, though very largely repainted, were also part of the historic structure of the Cathedral.

The ceilings

Back in 1994, we had realised that a serious amount of money would have to be raised to help us fund the restoration of our unique medieval Nave Ceiling. We also knew that the Presbytery and Apse Ceilings were very dirty. The Presbytery Ceiling structure and its original paint scheme date from the 1500s, while the existing, more recent painting dates from 1859. The Apse Ceiling dates from the fourteenth century, was repainted in 1856, and restored in 1956 (see illustrations left). During this last restoration, a layer of varnish had been applied to the Apse Ceiling that was wax based and easily absorbed dirt. The Presbytery Ceiling did not have this layer but, nevertheless, had also become discoloured and dirty. At the time, however, the most urgent matter was the Nave Ceiling: other issues would have to wait. The fire changed our repair agenda radically. For a start, we had to contemplate cleaning the Nave Ceiling for a second time. But also, through the generosity of many supporters and friends, we were able to raise additional funds and, with the very professional and pragmatic support of our insurers, we were able to restore areas of the Cathedral that would have been quite impossible to get to, from a financial point of view, for many years to come. The restoration of the other ceilings – of the Transepts, the Tower, the Presbytery and Apse – was a bonus which we had not expected and which helped lift our spirits considerably. The additional funding allowed us to take advantage of the presence of the scaffolding platforms throughout the Cathedral and carry out much of this extra work.

OVERLEAF

The Presbytery and Apse Ceilings. The picture of Christ and the Apostles on the Apse Ceiling, dating from 1500, was repainted in 1856 and 1936. The sixteenth-century Presbytery ceiling was repainted in 1859.

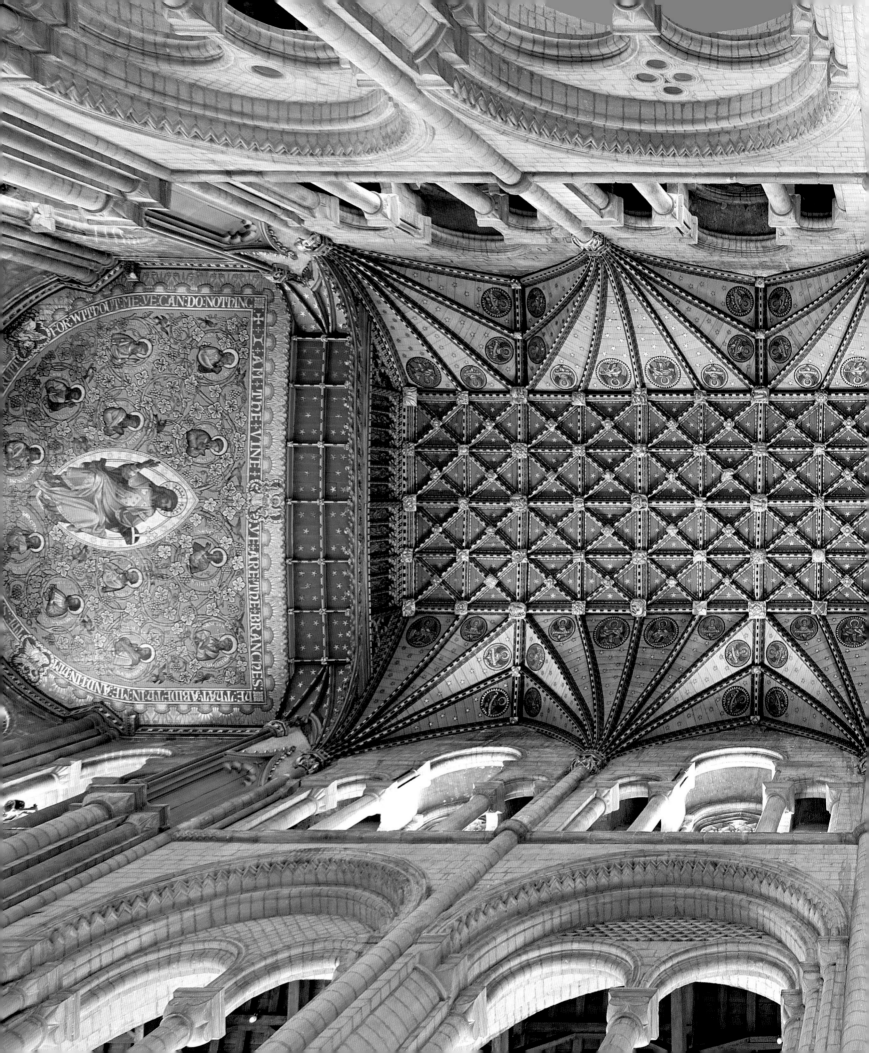

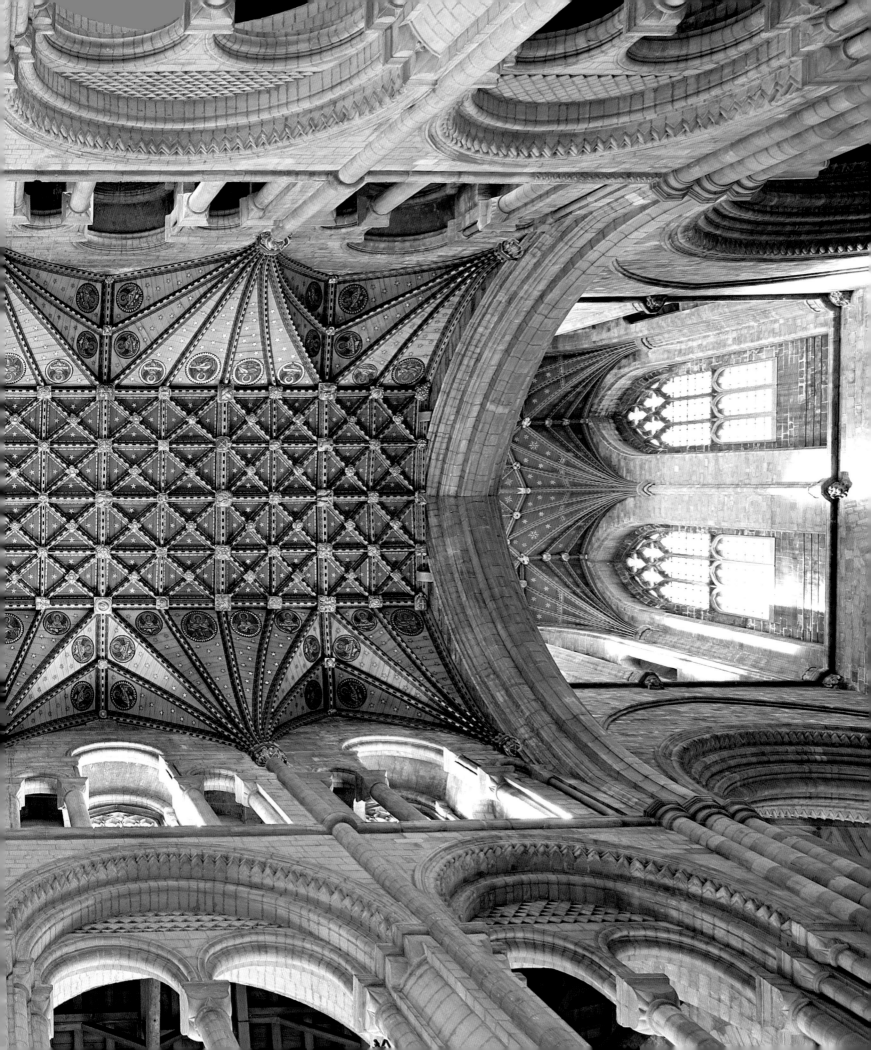

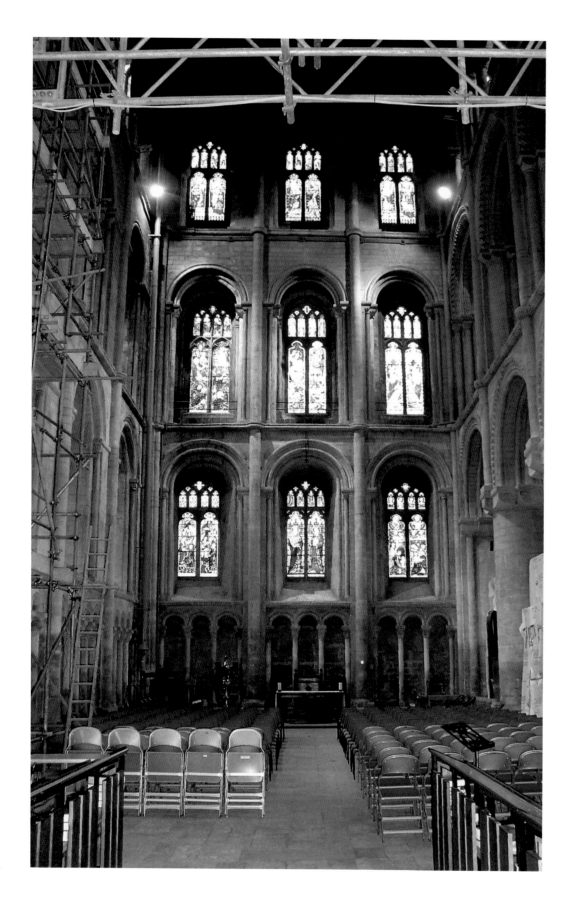

LEFT The North Transept seen from under the Central Tower scaffolding

ABOVE The Transept filled with scaffolding

RIGHT A photogrammetric survey of the Presbytery Ceiling being carried out from the cathedral floor

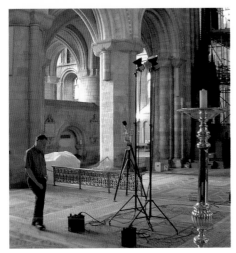

The Transepts

To the present-day visitor, the achievement accomplished in the restoration of the Transept Ceilings may not be very apparent. To people who knew the transepts before and just after the fire, the transformation is amazing. Those of us who climbed the scaffolding were able to appreciate the full impact of the fire and see the contrast between cleaned sections and areas yet to be tackled. While the 'before' panels looked very dirty indeed, the 'after' looked as though they had only just been placed into position. The difference was extraordinary. I could barely wait for the scaffolding to be taken down so that everyone could enjoy the sight. But it was almost a year after their erection before that could happen.

Peterborough Cathedral is rightly famous for its painted Nave Ceiling. Of less renown, even among those who worship regularly within its walls, are the Cathedral's Transept Ceilings, which were also, very probably, painted at the same time in the thirteenth century. However, they were repainted in the 1740s and again between 1826 and 1829; then in the 1880s, during the course of the reconstruction of the Central Tower, the paint was removed. A pre-1880s photograph of the North Transept (see overleaf, below left) vividly illustrates not only the cracks in the wall that occasioned the need for a major repair to the Central Tower, but also the painted patterns that formerly adorned the ceiling. During the recent cleaning process, our restorers discovered evidence of this painting and could just make out the pattern of the decorations. A photogrammetric drawing of the North Transept reveals what had previously been hidden and shows the sophisticated methods used to analyse and record the detail of these ceilings (see overleaf, below right). Though the photograph is only black and white, some indication of the vivid colours of the decoration are given in the report. It must have been most striking. The report produced by The Perry Lithgow Partnership in collaboration with Hugh Harrison, entitled 'Peterborough Cathedral: The Transept Ceilings', is a fascinating and thorough record of their work in investigating and cleaning the ceilings.

I cannot imagine that there are, or ever have been, many Deans who have had the privilege and opportunity to become so informed and familiar with the Cathedral in their care. The research and information unearthed in the process of cleaning and restoring the Transept Ceilings is a very good example. However, my late nineteenth-century predecessors must have learnt a great deal during the rebuilding and repairs to the Central Tower. Interestingly, after the repair to the Tower had been completed, there was a debate as to what should be done in the Transepts. The Perry Lithgow Partnership report notes that "In 1887 estimates were sought from a Peterborough firm for 'painting Transept ceiling to correspond

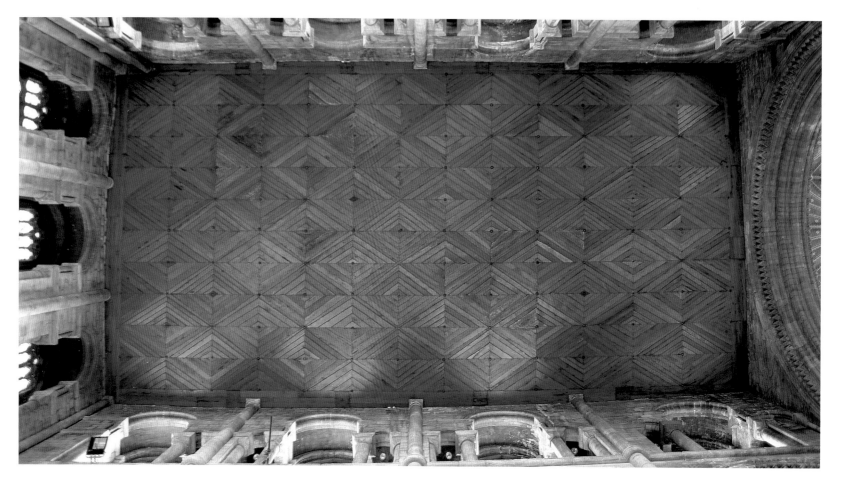

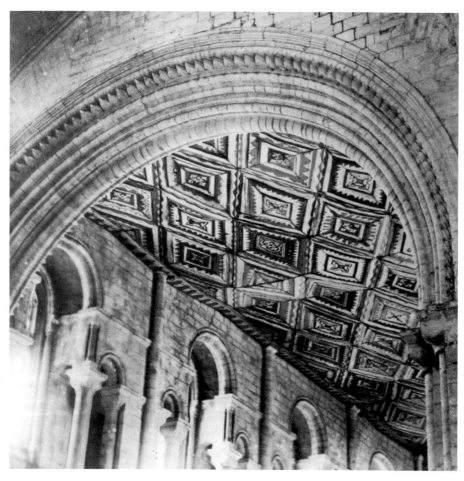

LEFT The North Transept Ceiling as it looks in the present day

FAR LEFT BELOW Pre-1880s photograph of the painted South Transept Ceiling

LEFT BELOW Photogrammetric diagram of how the painted Transept Ceiling might have looked

RIGHT The unpainted, wooden North Transept Ceiling

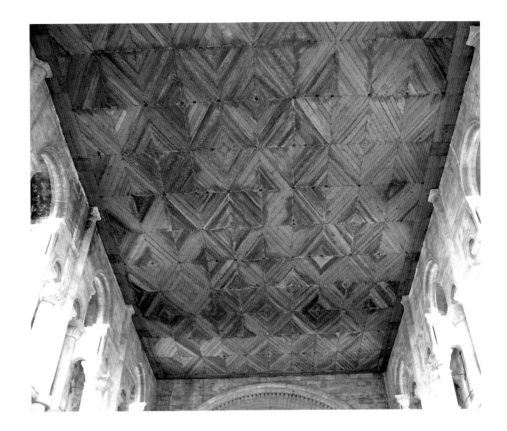

to old Transept". It may be of interest to know that the quotation was "£52/-/- for N. Transept, £45/-/- for S. Transept." However, it would appear that this was deemed too great a cost and the decision was made not to repaint the panels but to remove all the paint instead and leave a natural finish. Now that it is clean, the oak panelling does, indeed, look splendid (see illustrations this page and opposite), and it will be far less expensive to maintain for the generations to come.

Another interesting unearthing in the transepts was that of gunshot damage! Initially it was thought to have been made by the blunderbusses of Cromwell's soldiers. On closer inspection, however, the shot was found to be more modern – probably that of a marksman called in to get rid of birds. Birds always find their way into big buildings like cathedrals, but must have been a particular problem when the Cathedral was open to the elements during the nineteenth-century repair of the Central Tower.

Presbytery and Apse Ceilings

Hugh Harrison and The Perry Lithgow Partnership produced a further report on their work on the Presbytery and Apse Ceilings. Being able to examine and enjoy these ceilings at such close proximity was again a most fascinating experience. However, a rather alarming discovery was made, concerning the condition of the fixings of the bosses that decorate this part of the Cathedral. Many of these were

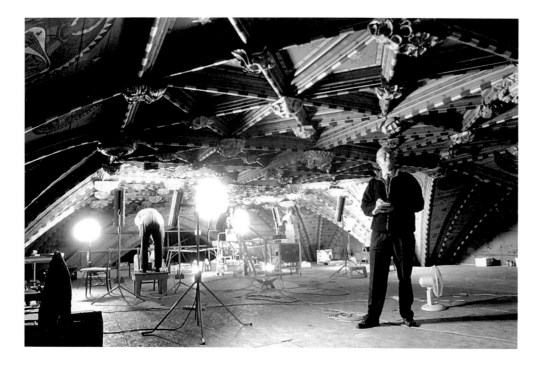
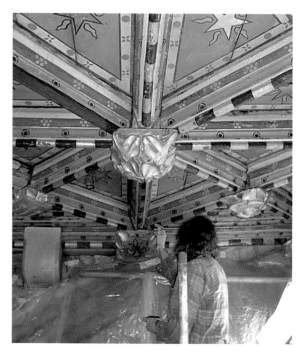
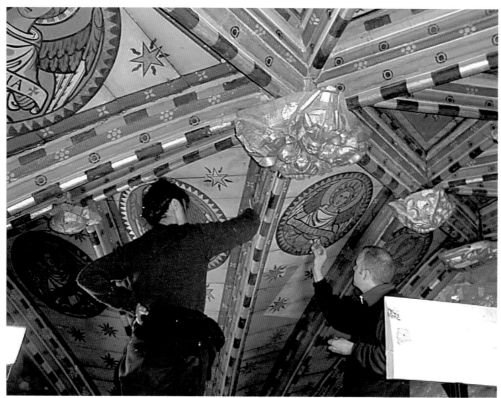
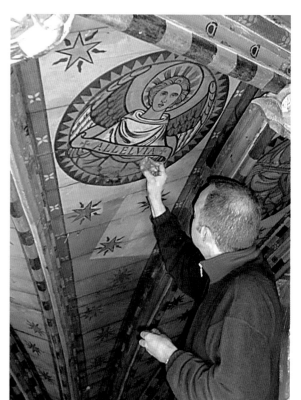

Geoff Sayers, Mark Perry, Sarah Livermore, Greg Howarth, Sasa Cosinova and Bianca Madden at work restoring the Presbytery Ceiling

BELOW RIGHT Two of the many bosses that adorn the Presbytery Ceiling

remarkably solid, large and very heavy structures measuring as much as 90 cm in diameter. They were held to the roof structure only by a false tenon and a pinned joint in the boss itself, and many of the pins were defective. Little had we realised the danger that hung by a thread above our heads. One of the heaviest bosses was particularly unstable, and might have fallen at any moment. After consultation with the appropriate controlling bodies, it was decided to add some stainless steel wire behind each of the bosses for added security. The wire is not visible from below but is a most necessary addition to the structure. This discovery was another example of God's providential care for us.

One of the most encouraging discoveries made, once the scaffolding had been erected and the restorers had had a chance to survey the ceilings, was, and I quote from the report, that there was "no evidence of active fungal decay and insect infestation or loose joints", except in a very small area on the Presbytery Ceiling.

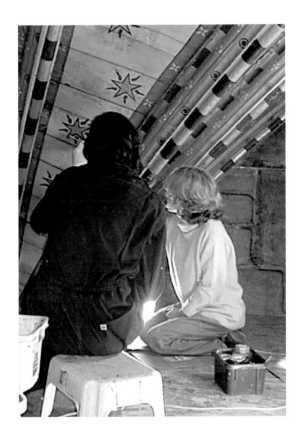

I had never fully appreciated quite how much effort and energy must have originally been expended on these ceilings, as it is difficult to see the detail of the work from floor level. I hope the photographs in this book will do justice to their beauty (see the illustrations on these and the following pages), although those who designed the decorations in this space, as well as elsewhere in the Cathedral, did not do so simply for human praise and for us to marvel at, but for the glory of God.

When I first toured the Cathedral on the day after the fire, it seemed to me that there were two areas most affected by the veil of soot. One, of course, was near the seat of the fire but the other, rather surprisingly, was at the eastern end of the Cathedral. In both areas, the soot had affected all the levels; floor, triforium and clerestory. Even before the scaffolding was erected to facilitate closer inspection, it seemed from the floor that the ceilings and walls of the Presbytery, Apse and

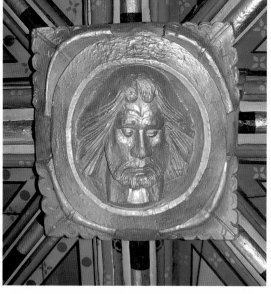

Bosses from the
Presbytery Ceiling:
A boss probably
representing the head of
Saint John the Baptist
on a platter

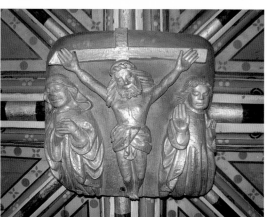

A boss representing
the Crucifixion

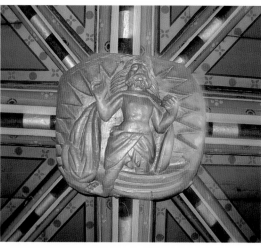

A boss representing
the fisherman St Peter
descending from his boat

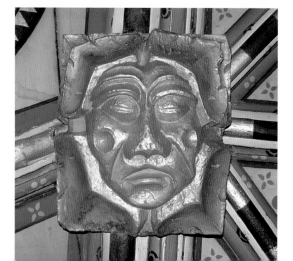

A boss apparently
representing the head
of a corpse

Central Tower were very badly coated. It appears that the fire had funnelled up and eastwards before being sucked out through the broken window. When this scaffolding was eventually removed, it was the new appearance of these areas that revealed just how dirty the Cathedral had been and what a difference the cleaning had made.

Lights

The fire damaged some of the electrical wiring and light fittings. An early decision was made not simply to repair the faulty electricals but to take this God-given opportunity to re-design and install a completely new lighting scheme for the whole building. We were able do this with funds from the 1996 Appeal, from The Friends of Peterborough Cathedral, and with money raised through the Emergency Appeal. To have such an impressive lighting scheme in place, ready for the final unveiling of our beautifully cleaned and restored Cathedral, was wonderful and once again a sign of God's providential care of our affairs.

6 / The Cathedral Organ

David Wilson (Asda Customer Services Manager) at the unveiling of the plaque recording the generosity of companies who donated to the Appeal through the Asda Foundation

Of great concern on the night of the fire was the Cathedral Organ. The seat of the fire was in the North Choir Aisle right next to the choir department of the organ. The oak casing was clearly badly burnt and charred, but the full extent of the damage was hidden by the oak panels used to encase the pipes, bellows and other elements of this section of the organ. The heat of the fire had been so intense that it had completely destroyed the panels on the outside of the casing which had listed the names of former abbots, bishops, priors and deans and the dates of their respective periods of office. Next to this list hung a plaque recording the generosity of a number of companies who had, through the Asda Foundation, raised £50,000 towards our 1996 Appeal. Fortunately, the plaque survived.

We feared the worst for the Organ when we saw just how much water had been used to extinguish the fire. On closer inspection, however, when the wooden panels had been removed, we could see that the heavy oak had acted as a very effective fire guard. The damage was less extensive than feared. It was examined by Mark Venning of Harrison & Harrison, the organ builders contracted by us to maintain the instrument. The fire and water had damaged the mechanism and wind system of the Choir Organ, but the pipe work had escaped the ravages of the flames and had been only slightly affected by the water. While the high pressure wind trunk between the blowers and the organ had been located at the heart of the fire and had been completely destroyed, the blowing chamber itself, thankfully, had escaped unharmed. I was greatly heartened by Mark Venning's report: "As far as the organ is concerned, there is no doubt whatsoever that it can be restored to its full glory". The report was dated 24 November 2001; the organ was not to return to "its full glory" until 2005.

Prior to the fire, we had begun to consider raising funds to enable us to put in hand a major cleaning of the organ and to make a few small adjustments that had become necessary. The fire meant a complete re-evaluation of what was now needed to bring this fine instrument back to "its full glory": it would have to be

The dismantled Organ stored on the North Triforium

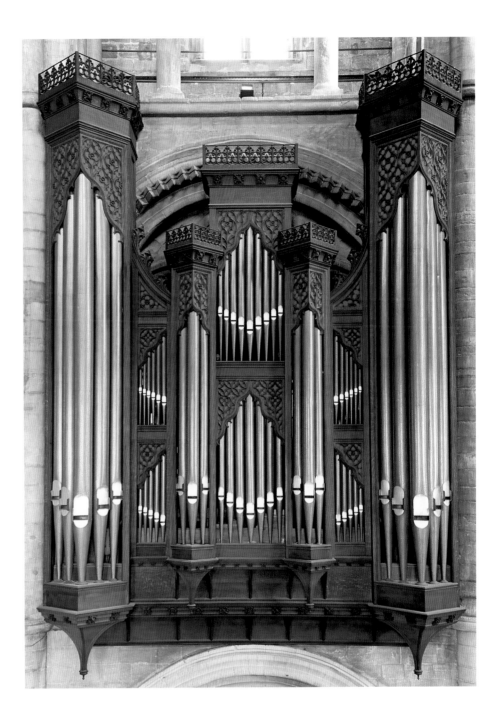

entirely dismantled. However, the work would cost about £60,000, nothing like the size of bill we had dreaded. By far the biggest issue was the damage caused by the smoke and its sticky, oily deposit. Parts of the Organ needed to be transported to Harrison & Harrison's workshops in Durham for repair, and the rest was removed to a specially fabricated store on the North Triforium, where the Organ 'chamber' and pipe-works were to be cleaned before being re-assembled.

Charred timber around the windpipe
of the Organ

The dismantling was a sad affair. The organ looked so lifeless. It hardly seemed possible that it would ever come to life again and sing, as it had, to the enrichment of worship. The cleaning process was a lengthy one. The problem was not just the size of the task but the need for the work to be fitted into the organ builder's already busy schedule. Mark Venning stated in his report that re-assembly of the organ could begin from Easter 2004 onwards, and would be completed by the end of the year.

We had a lot of waiting to do, but this period gave us an opportunity to consider whether any additional works should be carried out on the organ while it was in pieces. We had already given this some thought, even before the fire had occurred, and it was agreed that work on the pipes, console, electrical system and other elements that make up the inner working of an organ would be beneficial. The cost of all this work was beginning to mount up, but we had earmarked a very substantial grant of £500,000 from the Emergency Appeal for the organ.

After careful consideration it was agreed to make some other small but important additions to the pipework. We were to add a humidifier to the organ to help reduce maintenance costs, and reposition the console to allow better use of the space in this area. A communication system for the tuners was to be added - a small but important improvement very helpful in the tuners' regular monthly work attending to the instrument. It was also agreed that, when reassembled, the Choir Organ should be moved one bay westwards to allow for any future developments in the use of the Tower area. This would also be a better position for this section of the organ in relation to the organist, the choir and the congregation. None of these matters were controversial and so received approval from The Cathedrals Fabric Commission for England (CFCE), the regulatory body which deals with such matters for Cathedrals.

One recommended change which has not, as yet, received the necessary approval was a change of the organ's pitch. The present pitch is almost a semitone above concert pitch (A = 454 cps or five-eighths of a semitone). For a long time there had been no standard pitch for musical instruments, but over the years most of the organs in other cathedrals in the country had been changed or built to 'concert pitch'. Having an instrument that is sharp means it sounds out of tune for those musicians who have 'perfect' pitch and those whose ear is attuned to concert pitch. It also makes it impossible to play the organ with most instrumental ensembles, either for concerts or for Christian worship in the Cathedral, which is a great shame.

The refusal of the CFCE to allow us to re-pitch the organ was a big setback and disappointment. However, we moved forward with an optimistic heart, and

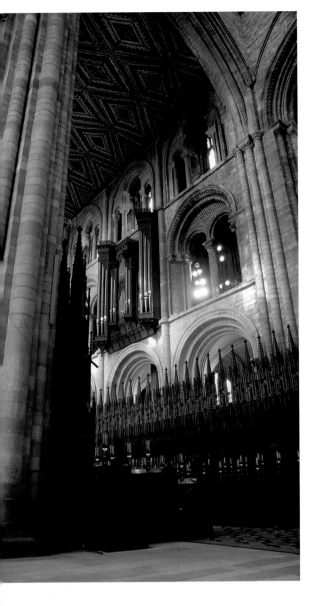

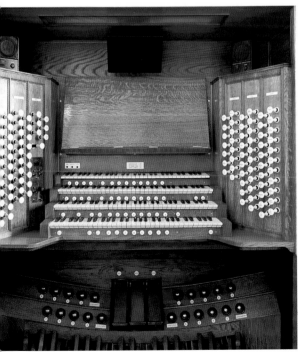

money has been kept aside in the event that a future attempt to obtain approval for the change in pitch proves successful.

The organ was finally restored and re-assembled, voiced and tuned. It was agreed that a special weekend of celebrations should be held to mark the completion of the restoration of the Cathedral. It was also agreed that there should be two focal points for this occasion: one, naturally, was to be an act of worship on the Sunday morning to acknowledge our great gratitude to Almighty God for his care of our building, that it was not destroyed by the fire, and that the restoration had been such a great success. The second focal point was to be the organ, such an important feature of the Cathedral and its worship, that had been silent for so long.

It was a great weekend of celebrations, opening with Choral Evensong on Friday 23 September 2005 and followed in the evening by the Inaugural Recital given by Olivier Latry (Titular Organist of the Cathedral of Notre-Dame, Paris). This proved to be an amazing occasion. It is quite impossible to convey with words the music that was created and the affect it had on the audience which filled the Cathedral. We were stunned by its brilliance. It was such a fitting climax to all the years of patient work that had gone into bringing not just the organ, but the Cathedral too, back to their "full glory".

On Saturday morning we enjoyed 'A Young Person's Guide to the Organ'; a special event for children and young people presented by children's TV presenter, Matt Edmundson. On the organ was theatre organist Richard Hills, and among the pipes were Keith Bowker and Andrew Scott from Harrison & Harrison. This was a terrific event for the children (and the young at heart!) and we all learnt a great deal about organs.

That afternoon, our own Director of Music, Andrew Reid, gave an Organ Recital before Choral Evensong. On the Saturday evening we enjoyed another feast at our Gala Concert, when the organ was played by James Vivian (Organist of Temple Church, London) and the Cathedral Choirs sang, supported by Mark Duthie, our Assistant Director of Music, and Oliver Waterer, the Assistant Organist. It was a rousing and very happy occasion.

On the Sunday, the Choir sang Choral Matins in the morning before leading worship at a Celebration Eucharist, and the day ended with Choral Evensong. It was most fitting that the special weekend was brought to a close on Sunday with worship to Almighty God, whose gracious, loving and caring hand had been upon us over these years of restoration.

ABOVE View of the Organ case and chamber from the South Transept
BELOW The Organ console after restoration

7 / Looking to the Future

Though this is the final chapter of my account, it cannot be the final chapter in the restoration of the Cathedral. A building as old as ours is bound to need more care. As I write, work is under way to repair the great West Front of the Cathedral, which, God willing, and as funding becomes available, will be completed over the next three years. But other works still remain to be tackled. The tesserae paving in the Presbytery is the most visible of these projects. The issue of re-pitching the organ has yet to be resolved, and there is urgent need for some more appropriate furniture for celebrating the Eucharist in the Nave.

So this story is incomplete: it is more a progress report. I hope and pray that this part of the story will encourage future generations, who have the responsibility of looking after this great Cathedral, to be as caring and generous as the present one. We have been blessed through the help and generosity of so many. Without them, I would not have a story to tell.

People of the Diocese used to complain to me that the Cathedral was in the wrong place, that that they would go to the Cathedral more often, and join in its worship and activities, if it were more conveniently located in the centre of the Diocese. The geography of the Diocese of Peterborough is such that the Cathedral is situated at its north-eastern tip; the Diocese of Lincoln is but eight miles to the north and the boundary with the Diocese of Ely only half a mile away across the river. Indeed, the Bishop of Peterborough is also an Honorary Assistant Bishop in the Diocese of Ely as so much of the city of Peterborough lies in Ely Diocese. Yet the Cathedral in Peterborough is meant to be "the centre of worship and mission of the Diocese".

We cannot move the Cathedral, and it is unlikely that we will ever be able to change the Diocesan boundaries. Yet I believe we can still be the "the centre of worship and mission of the Diocese". What is needed is a radical change in its ministry, that is, a drastic overhaul of its core activities and a spiritual renewal and restoration.

I pray and look forward to the day when what the Cathedral has to offer is of such significance that people flock from far to experience its vibrant ministry. It could happen. I pray it might. People travel long distances to experience the worship of the Taize

community and similarly to experience the ministry of healing at Lourdes. In Jesus' time on earth, the ministry he offered to people drew the crowds. They travelled miles on foot to be near him and to experience what he had to offer. When we say 'The Lord is here', I long for the day when people respond not just with the liturgical response, 'His Spirit is with us', but that they are moved to a spiritual renewal because they perceive that Jesus is truly there in the midst and near to them.

A cathedral is meant to influence the people who enter its doors, and the building itself should have an effect on people. I hope that the ministry at Peterborough Cathedral will help people to come to a living trust in Jesus Christ, who is the Saviour of all human kind.

So my prayer is that this story of the restoration of Peterborough Cathedral will be but 'Volume One'. One day, 'Volume Two', about the renewal of the 'Church', the body of Christ here in the Cathedral, and of its life and ministry, will be written and published. This time, it will not be about a building but about people who have met with God, who have been given a new life with a new perspective, new power to live it and a new prospect. And may the Living God bring this about and to his own glory be it. Amen.

The Rood Cross in the Nave. The crucifix was designed by George Pace, and the figure of Christ by Frank Roper, in 1975. The inscription beneath states, "The cross stands while the earth revolves"

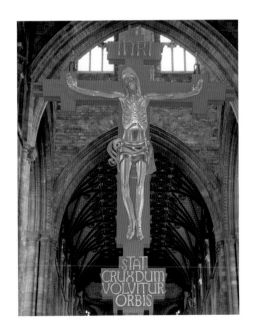

Peterborough Cathedral seen from the north-east

8 / The Painted Nave Ceiling

PAUL BINSKI

Introduction

Peterborough Cathedral is one of the greatest and best preserved Romanesque churches of northern Europe. Its style is representative of a Europe-wide movement which revolutionized church and castle building in England after the Norman Conquest in 1066. As an example of Romanesque architecture, Peterborough Cathedral – or Peterborough Abbey as it was known in the Middle Ages – ranks in purity and grandeur with Durham Cathedral. Peterborough was one of four exceptionally large and prestigious Benedictine monasteries in the east of England, the others being Bury St Edmunds, Ely and Norwich. The last two were formed as cathedrals by the Normans.

As well as being large, even by European standards – such churches as Norwich and Winchester competed in length with St Peter's in Rome – these buildings were united by similarities of style and function. They were staffed by monks living according to the Rule of Saint Benedict and were favoured by the saints of England. Bury holds the shrine of Saint Edmund, Ely that of Saint Etheldreda, and Norwich that of Saint William. Peterborough possessed the shrines of three minor saints, Kyneburga, Kyneswitha and Tibba, all local nuns, and was probably less important as a centre of pilgrimage than Bury or Ely, which possessed the relics of royal saints. Yet Peterborough, Bury and Ely were all conscious of their venerable standing as ancient monasteries, with Peterborough's origins lying in the seventh century, when the monastery was part of Mercia. This sense of heritage grew stronger in the twelfth and thirteenth centuries, when the great monastic chronicles were being written. The identity, power and liberty of such institutions were based on their view of the past. This is reflected in the art of Peterborough and, in particular, in its great Nave Ceiling.

The present church was constructed in a consistent style from the east to the west end from 1118, under the Norman Abbot John de Séez. The Nave was started

Peterborough Cathedral seen from the south-east

around the middle of the century. Small but significant changes to the design of the Nave towards the west end reveal the influence of Canterbury Cathedral, the most important new Benedictine church of the later twelfth century, partly rebuilt in the new French Gothic style after a fire in 1174. These details probably indicate the arrival from Canterbury of its former Prior, Benedict, who ruled Peterborough as Abbot from 1177 until 1194, and was one of the biographers of Canterbury's dazzling new saint, Thomas Becket (died 1170).

The link to Canterbury, which is also reflected in other aspects of the art of the church, serves to throw into relief the way in which the latest architectural fashions were already leaving Peterborough behind. The new Gothic style had as its central feature not so much bigger and better windows – the walls of the Transepts of Peterborough are already amazingly open to light – but daringly wide, high, strong and versatile stone vaults, stiffened by ribs. Even in the twelfth century commentators were alert to this new feature of French and English Gothic. At Ely, Norwich and Peterborough only the lower outer aisles had been vaulted in stone while the high central parts had all been covered with timber roofs and ceilings. As the events of 1174 at Canterbury must have shown, churches ceiled with wood were very vulnerable to fire; indeed a great fire in 1116 had preceded the reconstruction of Peterborough. The new light stone vaults, which separated the body of the church from the wooden roofs above, were far more fire-proof. For this reason, they had been used early on in French castle construction. We know at Peterborough that the Apse, the curved area at the east end behind the High Altar, was eventually given a rib vault. There may also have been an attempt to bring the church up to date by inserting a wooden or even stone vault over the Nave. Parts of the upper Nave walls were cut away to receive a vault, and the Nave walls seem to have buckled slightly as though they once bore a vault. In the wake of this, the present ceiling with its canted sides was installed and no further attempt was made to copy the arches and cones of a rib vault. Peterborough, therefore, remained a Romanesque church with wooden ceilings, as did Bury. Ely gained a beautiful Gothic east end in the thirteenth century, and Norwich, which had repeatedly been damaged by fire, was eventually vaulted throughout in stone.

In one important respect, however, the Gothic style did make an impression at Peterborough; it was the style chosen for its spectacular west front. This was built perhaps in the 1220s or 1230s, after completion of the Nave. The Cathedral had taken over a century to build. The front is an 'arch façade' consisting of three huge pointed arcades set sideways to the orientation of the church, a magnificent and grand idea which owed its inspiration to the twelfth-century west front of Lincoln Cathedral. Ornate figure sculpture was placed in arches and in the opening at the top of the façade, reminding us that the thirteenth century was a great

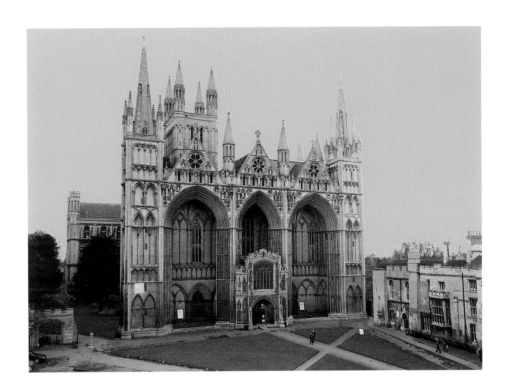

The Great West Front

age of sculpture. The central door had probably included an image of Saint Peter, the monastery's patron. On the sculpted, marble column base of the Cathedral's main door is a fascinating carved image of a man plunging downwards into the grip of demons. It might represent Simon Magus, who was defeated by Saint Peter, and it certainly reminds us of the medieval Church's belief in the omnipresence of evil and the need to defeat it.

The painted Nave Ceiling

Other than its great West Front, the work of art which really celebrates the Gothic age at Peterborough is the Cathedral's colossal, painted Nave Ceiling. We must try to imagine the Nave as it stood in the thirteenth century, covered by the ceiling and stretching all the way to a point just before the site of the present-day choir which roughly marks the location of the original monks' choir. Here there were screens which closed off the end of the Nave, together with a great Cross which marked the altar of the Holy Cross. In the Gothic era, lay people would not have witnessed the impressive vista right down to the east end that is afforded by the present arrangements. The sense would rather have been of two churches gathered under one roof, a church of the people and a more distant and mysterious church for the monks.

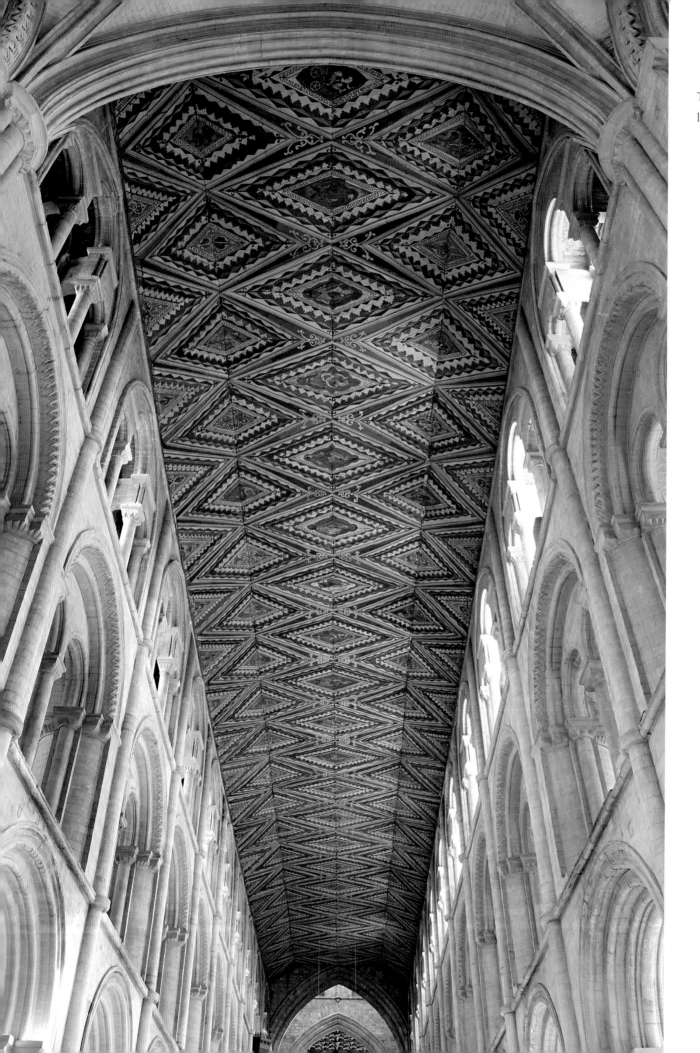

The Nave Ceiling,
looking east

Statue on the sculpted, marble column base at the Cathedral's main door of a man (perhaps Simon Magus) plunging downwards into the grip of demons

Its sheer scale distinguishes the Nave Ceiling from any other similar enterprise in Europe, for although the greatest painted church interiors were created in medieval Italy – the vaults of the basilica of San Francesco at Assisi, for example, painted completely in fresco – none is of such ambition. The painted wooden ceiling at Hildesheim in Germany is of about the same period, but, unlike Hildesheim, which is dominated by one huge image of the Tree of Jesse (the lineage of the House of David, Mary and Christ), the ceiling at Peterborough depicts many small subjects, grouped into themes. These include a set of representations of the Liberal Arts, unique to England.

The recent conservation has brought to bear on the ceiling all the wonders of modern technological investigation. We now understand far more about it than we did even a decade ago. For instance, we now know that the painting was done in linseed oil. Thanks to tree-ring analysis (dendrochronology) of the oak of which the ceiling is made, we also know more or less when it was painted and installed. The ceiling is made from oak imported from eastern Europe and is made of planking constructed in a manner not unlike that of medieval ships. The timber planks can be dated with such accuracy that we now know the order in which the ceiling was installed – from the east end of the Nave to the west.

The Nave Ceiling's date, style and patronage

The ceiling design can be read as a sequence of ten large diamonds, one per bay, each enclosing four smaller diamonds. The general effect is of a regular and luxurious pattern extending the length of the Nave, with no single strong emphasis. The patterning owes much to long standing traditions of decorative art. A painted ceiling was not necessarily a poor substitute for a stone vault. Vaults were, in some ways, harder to paint. Magnificent painted ceilings had been highly prized in the Romanesque period before the advent of rib vaulting. The Canterbury monk Gervase mentions the *"caelum egregia pictura decoratum"* [ceiling decorated with remarkable painting] which adorned Conrad's choir at Canterbury in 1107–26. This painted ceiling disappeared in the 1174 fire and nothing definite is known about its contents. But clearly it set a standard, and its memory may have been preserved at Peterborough through the agency of Abbot Benedict, who came from Canterbury.

Earlier authorities on English medieval painting such as C.J.P. Cave, T. Borenius and E.W. Tristram were inclined to date the ceiling within the first quarter of the thirteenth century. We now know that this is too early. Ian Tyers and his colleagues have shown, by means of dendrochronology, that the felling dates for the wood used, working from east to west, were c. 1228 (bay 1), c. 1230–38 (bays 3–6),

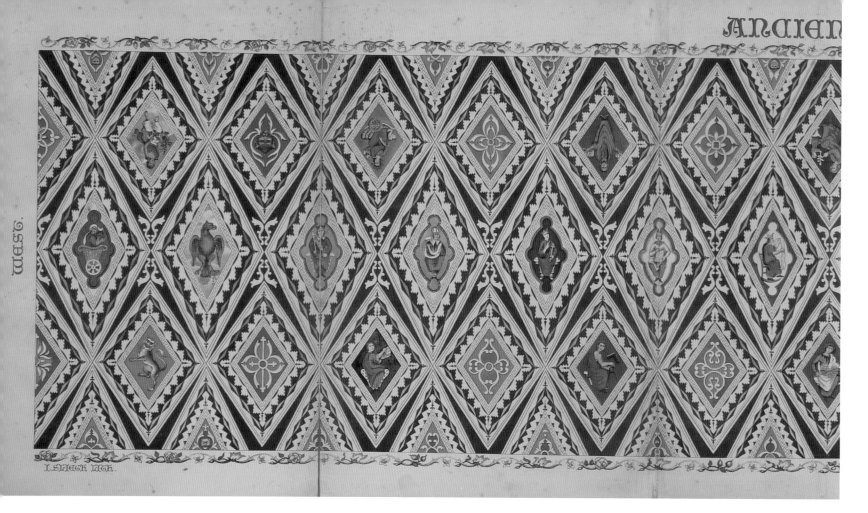

WEST.

I.SMEGH LITH.

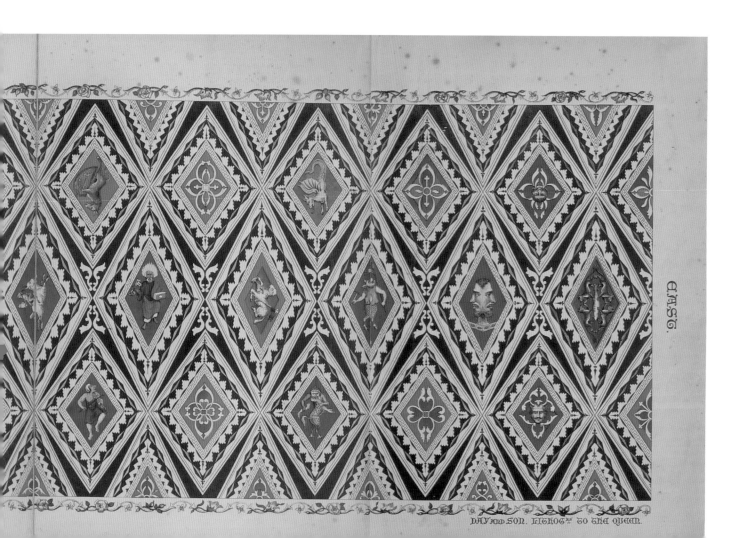

EAST.

DAY AND SON, LITHOGʳˢ TO THE QUEEN.

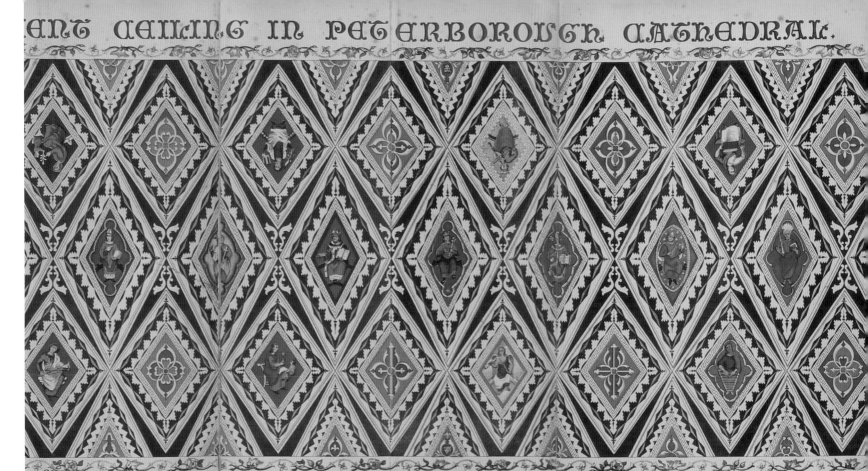

Nineteenth-century lithographic drawing, *Ancient Painted Ceiling in The Nave of Peterborough Cathedral*, by W. Strickland

and from the 1230s (bays 7 onwards). This strongly implies an east-west order of construction and painting, several felling phases, and the importation of the boards in batches starting from the 1230s. Therefore, the ceiling must have taken several years to execute. It was probably painted partly or wholly on the ground, before being hoisted up. What could, at first sight, be taken for a splendid Romanesque work of art was in fact completed nearer the middle of the thirteenth century.

One problem in assessing the ceiling as a medieval work of art lies in the fact that it was rather poorly repainted in both the eighteenth and the nineteenth centuries. This makes the usual art historical method of comparing styles to arrive at a date harder than usual. But many motifs, at least in outline, seem to have survived these repaintings, and many seem to be connected to illuminated manuscripts. Beautifully illuminated books, which were safely stored in libraries have survived in far greater quantities than any other medieval art form. These connections are typical of the period – things tend to share a common 'look' even

EAST END

King with torch

Symphonie
Dulcimer

St Paul

Ape holding owl
and riding goat

Ass with harp
Fiddle

King with torch

Symphonie

St Paul

Ape holding owl

Ass with harp

Dulcimer

and riding goat

Fiddle

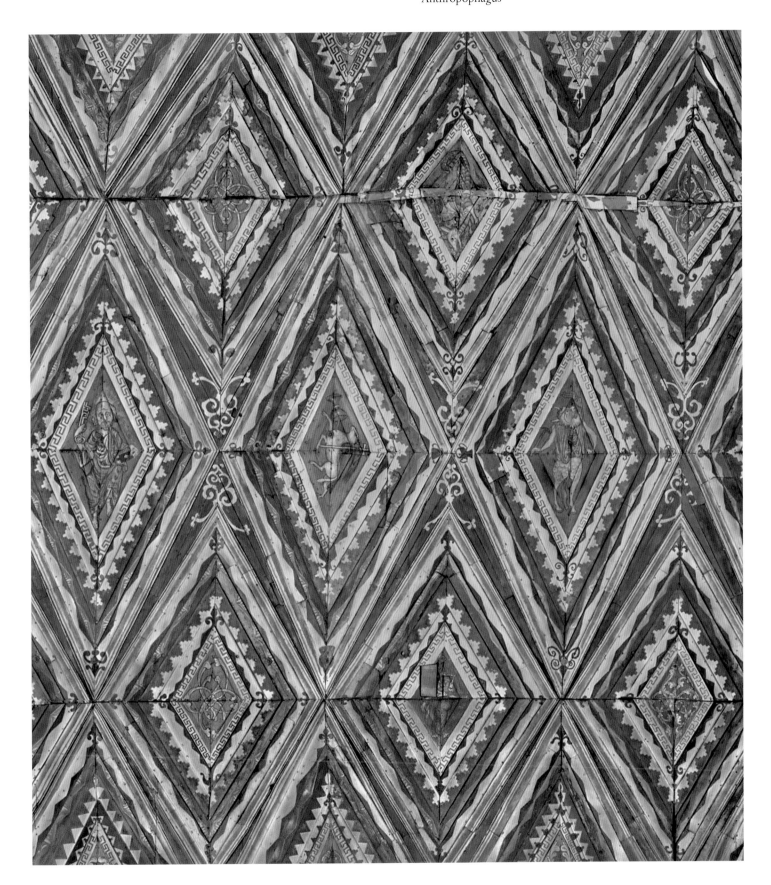

Janus

Green Man

Green Man

Fish and

Lions

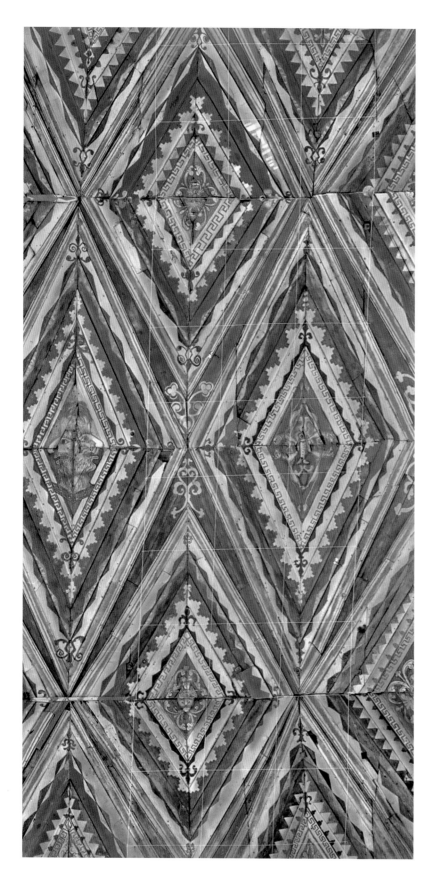

though the scale of the art may be widely divergent.

Useful comparisons can be made with manuscripts created for Peterborough and St Neots in the years around 1220. The Psalms formed the centre of medieval monastic worship and were collected together in beautiful illustrated Psalters. The first of these which bear resemblance to the ceiling is a Psalter in the Society of Antiquaries of London, MS 59, made for Peterborough Abbey after 1220. It includes a fourteenth-century inscription that it was "the Psalter of Abbot Robert of Lindsey". The second is a Psalter made for Peterborough now in the Fitzwilliam Museum, Cambridge, MS 12, similarly datable to around 1220 and decorated by the same artists. The former sacrist, Robert of Lindsey, was Abbot from 1214 to 1222, and if the inscription in the Society of Antiquaries MS can be relied upon the book must be dated before 1222. The Fitzwilliam Psalter has no such inscription of ownership but its calendar includes the Translation of Saint Thomas of Canterbury and the feast of Saint Hugh of Lincoln in the original hand and was therefore made after 1220, though how long after is unclear. Regarding the ceiling, we note the following connections with these two Peterborough books. The *Beatus* initial to Psalm 1 on f. 38v of the Society of Antiquaries manuscript comprises a large B with round and trefoiled medallions in the frame containing King David, Prophets and musicians. The symphonie players in the lower medallion, and their instruments, resemble the figure and attribute of Music on the ceiling. The head of the grieving John in the Crucifixion on f. 35v is close to that of the dulcimer player on the north side of the ceiling, next to the angel musician. The *Beatus* initial for Psalm 1 on fol. 12v of the Fitzwilliam MS has a stem containing beautiful symmetrical curling fronds with trefoil pads which provide a very close analogy to the corresponding foliage motifs on the ceiling; the same applies to the more complex tendril motifs in the D of Psalm 26, f. 41v. The short red sceptres held by Mercy and Truth in the lower lobe of the B of *Beatus* are like the sceptres held by the kings, and particularly by the figure of Rhetoric on the ceiling.

Other forms also signal a date in or around the second quarter of the thirteenth century. Thus the lobed mandalas around some of the figures on the central row recur in the Sarum group of manuscripts of the 1250s, the posture of the king carrying the flaming lamp with one foot raised above another becomes common in the second quarter of the century, as on the West Front sculptures at Wells (1220s–40s) and in the work of William de Brailes (Oxford, New College MS 322, fol. 41v). The use of symmetrical coils of foliage ending in rounded trefoil pads is uncommon before about 1200. The original low-relief crocket and finial-like foliage which, during cleaning, was shown to underlie the overpainted strips around the lozenges also conforms to foliage designs of the first half of the thirteenth

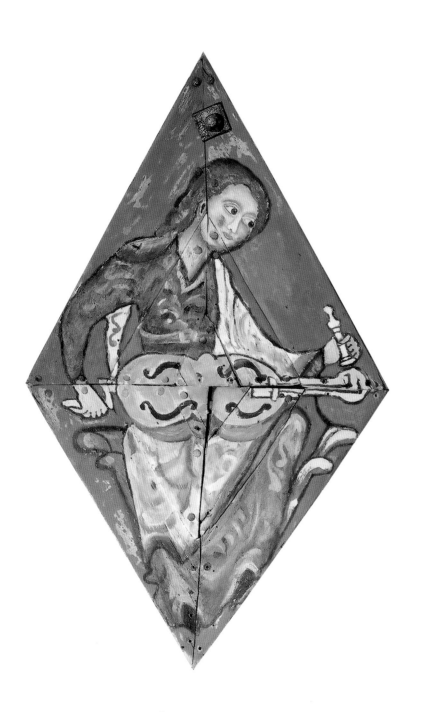

Music, playing an organistrum

Lozenge from the Peterborough Nave Ceiling

Complex tendril motif in the initial D of Psalm 26, f. 41v in

a Psalter made for Peterborough, after 1220

Fitzwilliam Museum, Cambridge, MS 12

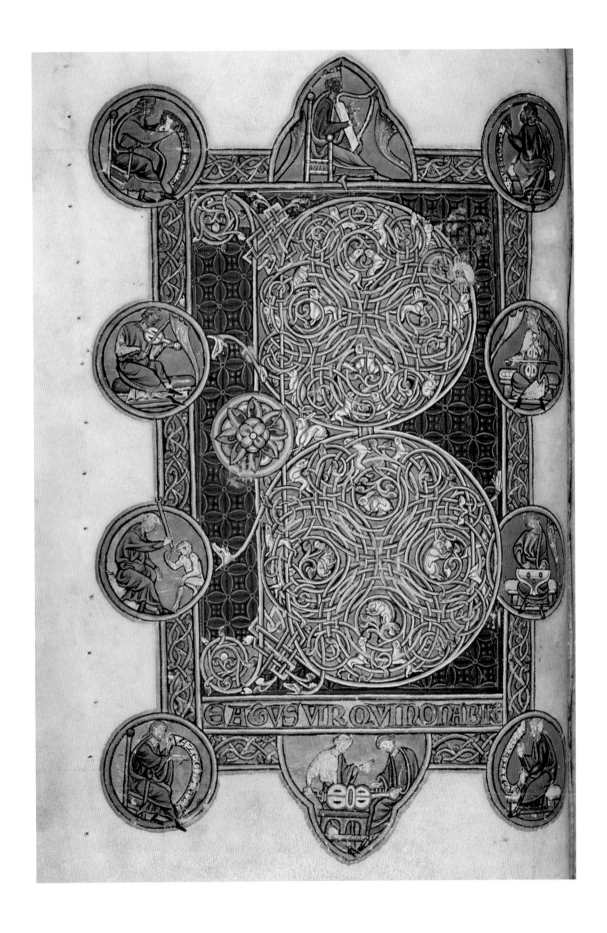

The *Beatus* initial
of Psalm 1, f. 38v of the
Lindsey Psalter, after 1220
Society of Antiquaries,
London, MS 12

Decorative motif
Lozenge from
Peterborough Nave
Ceiling

A sceptre-wielding king

Part of a lozenge from the Peterborough Nave Ceiling

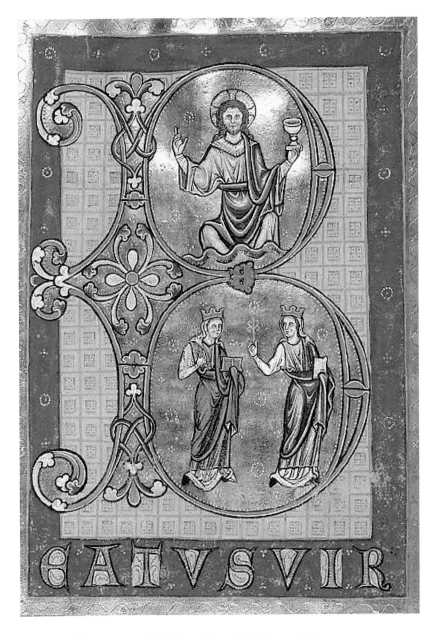

The *Beatus* initial of Psalm 1, f. 12v of a Psalter made for

Peterborough after 1220

Fitwilliam Museum, Cambridge, MS 12

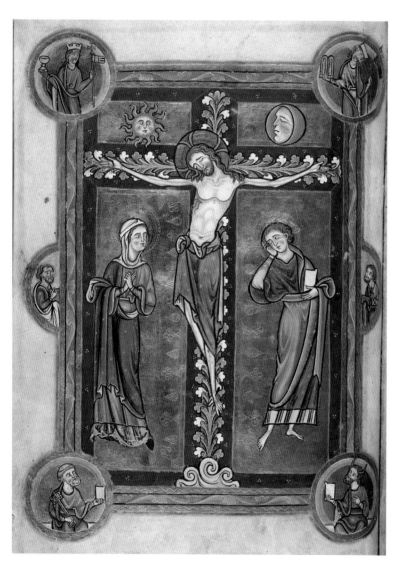

The Crucifixion, f. 35v of the Lindsey Psalter, after 1220

Society of Antiquaries, London, MS 59

Dulcimer player

Lozenge from Peterborough Nave Ceiling

century, though its origins lie in (amongst other places) the borders of the twelfth-century glazing in the clerestory of the South Transept at Canterbury Cathedral. Crockets on triangular gables do not become common until the 1250s.

In sum, we now have two methods of dating the ceiling which corroborate the results of one another – by style, showing a date around or after 1220 and into the middle of the century; and by dendrochronology, showing a date after 1228 and also into the middle of the century. This date-range suggests that, while the initiation of the ceiling may have been possible during the abbacies of Robert of Lindsey (1214–22), Alexander of Holderness (1222–26) and Martin of Ramsey (1226–33), it was probably not begun before that of Walter of Bury St Edmunds (1233–45).

Robert of Lindsey was the first abbot to consider the issue of the church's large-scale decoration after the completion of the Nave. The thirteenth-century Peterborough chronicler Robert of Swaffham observed that when Robert was sacrist, before 1214, he provided more than thirty stained-glass windows, embroidery, and new imagery for the church and, in addition, he whitewashed the vaults of the retrochoir.

This burst of activity in the first quarter of the century probably has an explanation. Several major Benedictine churches were undergoing redecoration in these years, following the completion of the works at Canterbury: the same sort of work is recorded in the famous chronicle of the abbots of St Albans, the *Gesta abbatum*, under Abbot William of Trumpington (1214–35). In many ways, Canterbury, with its new Gothic vaulted church, ornate mosaic floors, brilliant, large stained glass windows and dazzling shrine, was a model which goaded all the self-respecting Benedictine churches of England into action. As we have seen, there had been links between Canterbury and Peterborough since the later twelfth century. Peterborough is thus witness to the renaissance of medieval art brought about, indirectly, by the cult of Saint Thomas.

While, clearly, engaged in concerted works in the 1230s and 1240s, Abbot Walter also donated the metalwork feretories for Saints Kyneburga, Kyneswitha and Tibba. This act could well reflect competition, specifically with the Benedictines at Ely where, under Bishop Hugh of Northwold, the new retrochoir for Saints Withburga, Ermenilda and Etheldreda had been begun in 1234. Ely was closer than Canterbury, and being wholly of Gothic style, was also significantly more 'modern', Walter also rebuilt the refectory at Peterborough with its beautiful portal, and contributed to the *opus stallorum*, that is, a set of new choir stalls which may have needed to accommodate the expansion by thirty of the number of monks during his abbacy.

This extension of the choir stalls is important. The choir at Peterborough

always stood in the two easternmost bays of the Nave, a fashion traditional to many English churches. The record that Walter rebuilt the choir stalls partly or wholly in the period 1233– 45 tallies well with the proposition that a start was made on work to the ceiling above in the same period. In effect, he redid the decoration and furnishing of the Nave in its entirety. Interestingly his choir stalls, though almost totally destroyed (a fragment of one of them is embedded into the wood-work in the north transept), are known to have been decorated with biblical an-tetypes – events in the Old Testament foreshadowing those in the New. This scheme of 'typology' between the two parts of the Bible is almost identical to the programme for the glazing at Canterbury Cathedral carried out in the twelfth cen-tury. Perhaps Benedict had been familiar with this as early as the 1170s. In any event the Peterborough ceiling may have connected with the church's, now lost, choir stalls.

A picture of the origins of the ceiling is starting to build up. Before we go on, here it is in summary: first, the ceiling is painted in a style known to have been prevalent in the Fenland area in the 1220s; secondly, it was part of a more gen-eral campaign to redecorate the Nave and choir, which began in the 1230s but which may have been realised only gradually over the next decade or two; thirdly, de-spite the length of campaigns needed to paint and install the ceiling, the painters were working in substantially consistent techniques and to a fixed range of car-toons for standard ornament; fourthly, its patronage was East Anglian, and indeed the work was probably begun under Walter of Bury St Edmunds, Abbot 1233–45.

The Nave Ceiling's themes

In England the only comparisons from the period are provided by rib-vault dec-orations, such as those of about 1240 in the eastern limb and transepts of Salisbury Cathedral, the late thirteenth-century wooden painted vaults of the presbytery at St Albans Abbey, and the fragments from the wooden chapter-house vault of York Minster of c. 1290. The Salisbury material is very formally arranged in medal-lions on the vault webs. Its themes were calm and solemn: Christ in Majesty at the crossing before the High Altar, major and minor Prophets in the choir, angels with attributes in the transepts and the Labours of the Months at the east end. York chapter house had a pot pourri including Saints Peter, Paul, William of York; Saints Edmund, Ecclesia, Synagoga; Saint John the Baptist; Moses; Saints Margaret, Catherine, Mary Magdalen; angels; and other figures including a merman, with a central boss of the Agnus Dei. These examples indicate that there were no rules for decorating large vaults and ceilings, though there may have been common themes.

Goat-monkey-owl

Lozenge from the east end of the Nave Ceiling

Peterborough has a regular pattern of lozenges ornamented originally with crocket borders and finials. Thus Peterborough, as we have said, is quite unlike the contemporaneous ceiling at St Michael's, Hildesheim, which is very formally arranged around the large central motif of a Tree of Jesse. This has a logical start (Adam and Eve) and finish (Christ in Majesty) and a clear arrangement in large geometrical figures. The significant later twelfth-century painted wooden ceiling at St Martin, Zillis (Grisons), is divided into square panels enclosing scenes with Christ and Saint Martin, as well as mermen. The pretty ceiling at Dädesjö in Sweden, also of this period, contains bust- and full-length angels and scenes from the Life of the Virgin Mary and the Nativity of Christ arranged in roundels with foliage, in the manner of book illumination. At Peterborough, smaller units like these were again chosen, presumably for their flexibility.

Compartmentalized ceilings with small topics or commonplaces within them had been prevalent in Roman painting. A first-century diamond pattern with figures from the Villa Varano, Stabiae may be seen in Naples, and vaults or ceilings with coffering or other forms of enclosure with commonplaces include the first-century cryptoporticus of the Golden House in Rome. Though such examples were not known directly at Peterborough similar traditions persisted in ceiling and floor design in Western European medieval art. There is at least one clue that whoever drew up the scheme for the ceiling was aware, directly or indirectly, of subjects which had a long ancestry in medieval and pre-medieval art. It is above

all the naughtier subjects on the ceiling – and there are a few – that are a sign of this. One good word to describe these subjects, which catches the sense of their origins in pre-Christian art, is 'antics', derived from the word 'antique' and relating to the mischievous topics in classical and, in particular, Roman art. A fine example, on the ceiling at the east end, is the goat-monkey-owl scene in which a goat is straddled backwards by a monkey holding up an owl. A subject rather like this, a second-century Cupid riding sideways on a goat and holding a mask, is painted in a house beneath the baths of Caracalla in Rome.

Even the patterning of the ceiling might suggest emulation of antique art. Interlocked diamond patterns were also known on Roman mosaic floors and on painted walls and ceilings. The late twelfth and early thirteenth centuries witnessed a renaissance of ornate figurative pavements in Benedictine circles at Canterbury, Westminster and at Reims and St Omer in northern France – in buildings in which the widespread introduction of rib vaults precluded large painted ceilings. There was no tradition of such pavements at Peterborough, but such floors were widely admired in the Benedictine community, precisely as invocations of Roman or Byzantine art, and need to be taken into account in regard to the choice of topics on the Peterborough ceiling.

In any event we can appreciate the ceiling by reference to three themes – power, knowledge and morality.

Power: Church and State

The first obvious theme is to be found on the long central backbone of the ceiling, in the row of kings, bishops and archbishops along the spine of the western and central portion of the ceiling. None of these eleven figures (six kings, three bishops and two archbishops) carries an identifiable attribute, and no evidence has suggested the presence of inscriptions on the ceiling. The kings and prelates are paired in peaceable dialogue. This is, without doubt, a picture of harmony and continuity. However, a biblical iconography of filiation, such as the Kings of Judah or a Jesse Tree, is ruled out by the bishops. A gallery of paired kings and high churchmen is much more likely to be historical in nature: the later thirteenth-century pulpitum at Salisbury cathedral is reputed to have had a gallery of kings, and, by 1295, there was a similar such gallery in Peterborough's own late thirteenth-century Lady Chapel. At Peterborough the number and selection of figures seems quite particular. The number of figures precludes a straightforward representation of the Kings of England since the Conquest. Instead, it could indicate founder or benefactor iconography. Hugh Candidus, Peterborough's great medieval chronicler, described the roles of King Oswald, Kings Oswy, Peada, Wulfere and Ethelred,

their subject kings Sebbi and Sighere, and eventually King Edgar – from which a cast of a half-dozen figures is easy to establish – in the foundation of the abbey and the establishment of its rights. The two archbishops are perhaps Deusdedit and Theodore of Canterbury, and the bishops might be those cited in Candidus – Ithamar of Rochester, Wini of London, Jaruman of Mercia, Tuda of Lindisfarne and so on. Peterborough's kings and bishops are, by this reading, the figures involved in the early foundation and enrichment of the house, and in the defence of its privileges. Later examples of monumental paintings arranged in a sequence of alternating kings and bishops or abbots include the interior entrance murals of about 1290 of the chapter house of York Minster, as recorded by John Carter, and the Westminster Abbey sedilia, of about 1307.

So far as we can tell, the Nave Ceiling does not include local saints. Saint Peter is present with Saint Paul, but neither Saint Oswald (whose arm-relic was a treasure of the house), nor Saints Kyneburga, Kyneswitha and Tibba, nor Saint Andrew appear; nor does it seem that Saint Thomas of Canterbury, who enjoyed a cult at Peterborough, is present. Arguably, these subjects were painted on the lost medieval Presbytery Ceiling nearer the shrines and altars of the church.

The key point about the kings and bishops at the very centre of the scheme is that they show how Church and State had moved, in the thirteenth century, towards an uneasy relationship of cooperation following the turbulence of the Becket controversy – which had been about the balance of power of the two forces of religion and politics – and the reign of King John (died 1216), which had witnessed an interdict or closure of the English Church by the Pope in response to John's tyranny over the Church. In reality, things were never to be easy between kings and bishops, or monks. The ideal was that the Church should be protected by kings as defenders of the Faith. But England, in the thirteenth century, was dominated by a powerful central government jealous of the Church's rights and powers. In the sixteenth century, the State triumphed over the monasteries, and the monasteries, including Peterborough, were dissolved. At Peterborough, the line of kings and bishops attempts to depict an ideal axis and balance of power which may not have existed in reality. It also advertises the antiquity of the house. As discussed earlier, the identity, power and liberty of such institutions was based on their view of their past.

Knowledge: the Liberal Arts

Another institution which was problematic in the thirteenth century, from the point of view of both Church and State, was the University, which, at such places as Paris and Oxford, was growing rapidly. In England, the Universities of Oxford

and Cambridge remained distant from diocesan power, and above all from the controlling power of the Crown at Westminster. The cathedrals of the period supported learning in their schools; Lincoln and Salisbury were important in this regard. Unlike cathedrals, however, monasteries or abbeys had no pastoral or educational duties and supported no such schools. In a sense, monasteries were being left behind and were no longer the great centres of learning they had once been. Monasticism still had its own means and style of education, relying on Bible reading and a grasp of Latin grammar. Monks tended to be the historians of the day, perhaps because, unlike busy cathedral canons, they had the time to compile and write books.

It is therefore curious that Peterborough, not then a cathedral but a monastery with no school or intellectual traditions, should have been the place to possess the only artistic display of the Liberal Arts in England in this period. The Liberal Arts, so-called to distinguish them from the mechanical arts, were essentially pursuits of the mind rather than of the hand, and were divided into two parts. These were, first, the three arts of language, including the fixed rules of Grammar and Logic (or 'dialectic') and the presentational art of Rhetoric (the flexible art of getting a message across to an audience). These formed the so-called *trivium*. Second were the four arts of eternal numerical quantities, Geometry, Arithmetic, Music and Astronomy, the *quadrivium*. The division is a little like that of modern arts and sciences. The Arts were the basis of the schools' curriculum.

Peterborough's Arts are the only important monumental instance of the subject in England. The personifications accompany the kings and bishops in the western half of the ceiling, falling into two triangular formations on the ceiling's northern and southern perimeters. To the west, the *quadrivium* is disposed in a triangle with its base along the north side, while the *trivium* is to the east. Being uneven in numbers, the arts are laid out lopsidedly. The recent cleaning of the images has not changed or cast doubt on their attributes and identification. From the *quadrivium*, Geometry and Music are immediately recognisable by their attributes; a pair of compasses and a set square, and an organistrum. Astronomy, to the west, has been extensively repainted but appears to have held up an object, perhaps originally a sphere; Arithmetic has both arms raised, holding in her hands two attributes, of which one is probably an abacus. To the east, in the *trivium*, Rhetoric holds her usual attributes of tablets and stylus, and Grammar holds her disciplinary palmer and pupil. Grammar was literally beaten into students. Similar palmers or ferules for the chastisement of pupils, dating to the fourteenth century, were found in the drain of a city school in Lübeck in 1866. Logic or Dialectic makes a gesture of instruction to a tonsured clerk on a pedestal, who holds up to her a curious crocketted pyramidal object, the nature of which has

not been elucidated by the cleaning.

The Liberal Arts were an element of the noble literary and scientific inheritance of the ancient world preserved in the monasteries of the Middle Ages. In the twelfth and thirteenth centuries, European culture generally was taking new interest in this heritage – in pure forms of the Latin language, in Roman literature and rhetoric, and in the arts of the past. Historians have even spoken of a 'Renaissance of the twelfth century' anticipating that of Italy, three centuries later. Both belonged to a single, recognisable European tradition of arts and letters based on Latin learning. Not surprisingly, pictures of the Liberal Arts were quite popular in the late twelfth and early thirteenth centuries in sculpture, illumination, metalwork and even floor mosaics made elsewhere in Europe. Why they were not more commonly shown in England is a puzzle.

At the west end of the ceiling, and very substantially repainted, were two other topics which also point to a love of classical learning and its techniques, of which personification (illustrating abstract ideas or things as people) was one. So we find the Sun and Moon to the west of the arts, the Sun on the south side falling opposite Astronomy. Each is placed in a chariot, both of which lack their full complement of four horses and two oxen respectively. Yet there is no reason to doubt the authenticity of their general appearance. They are festive, pseudo-antique personifications that hint at a more distinguished ancestry. In this guise their origin is Carolingian (that is, in ninth-century France): we find charioteer personifications of the sun and moon in the ninth-century so-called Liuthard group of carved ivories. Only one early East Anglian instance is known; the now lost (but recorded) eleventh-century metal frontal of the High Altar at Ely, which probably derived from the same type of source.

Peterborough's representation of knowledge was not aimed at the generality of people who entered this part of the Nave to the west of the great screens which shut off the choir and the monks further to the east. On the contrary, it was a consciously intellectual theme that could still only be understood by those who could read Latin.

Morality: monks and marginalia

The same rather enclosed and learned Latin culture also produced the topsy-turvy images which feature at the end of the Nave over and nearest to the monks' church. This is not a coincidence. By modern standards, medieval monasticism was puritanical. To the monastic mentality, the body and its appetites were a threat to the purity of the spirit and the life of the mind. But this did not mean that images of sin, vice, carnality and ordinary humour were censored. On the

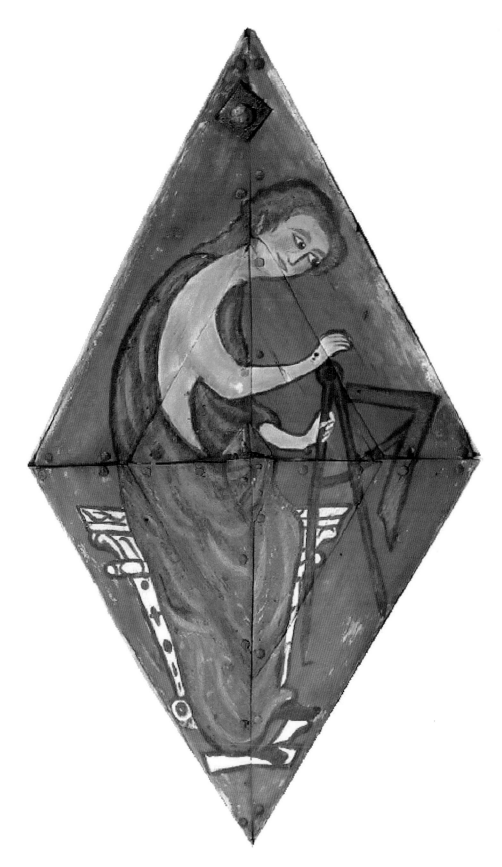

Geometry,
recognisable by the
attributes of a pair
of compasses and
set square
Lozenge from the
Peterborough Nave
Ceiling

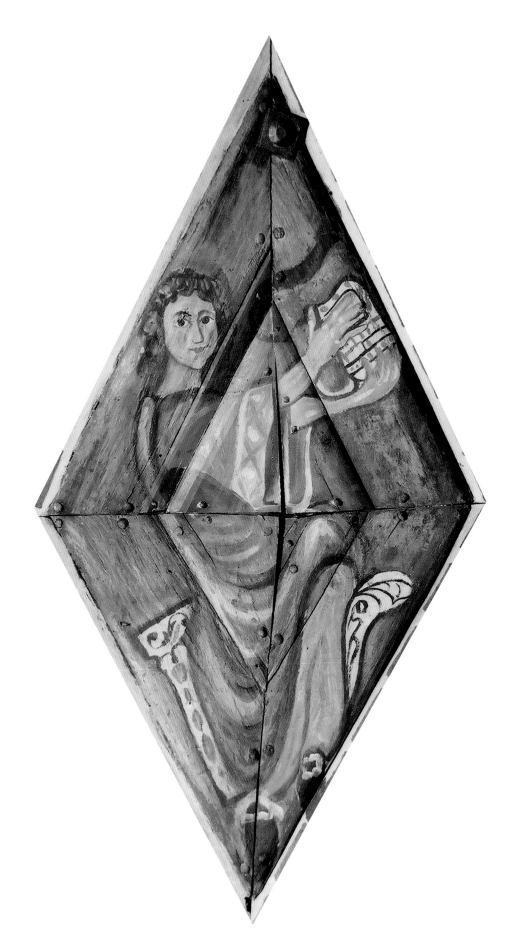

Astronomy
(the figure has been
extensively
repainted but seems
to have once held up
a sphere)
Lozenge from the
Peterborough Nave
Ceiling

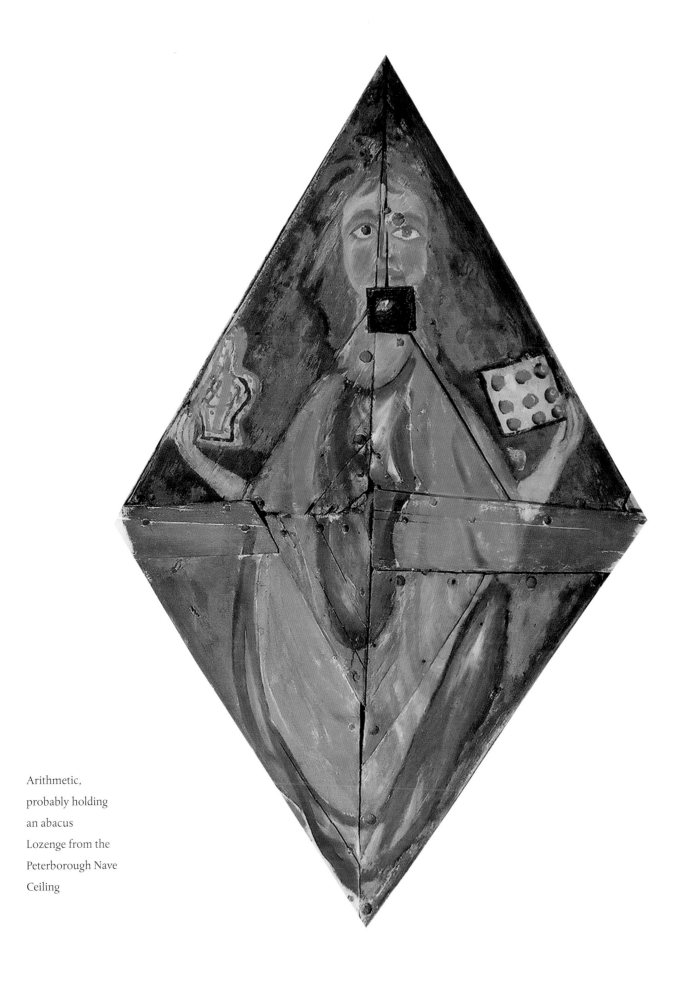

Arithmetic,
probably holding
an abacus
Lozenge from the
Peterborough Nave
Ceiling

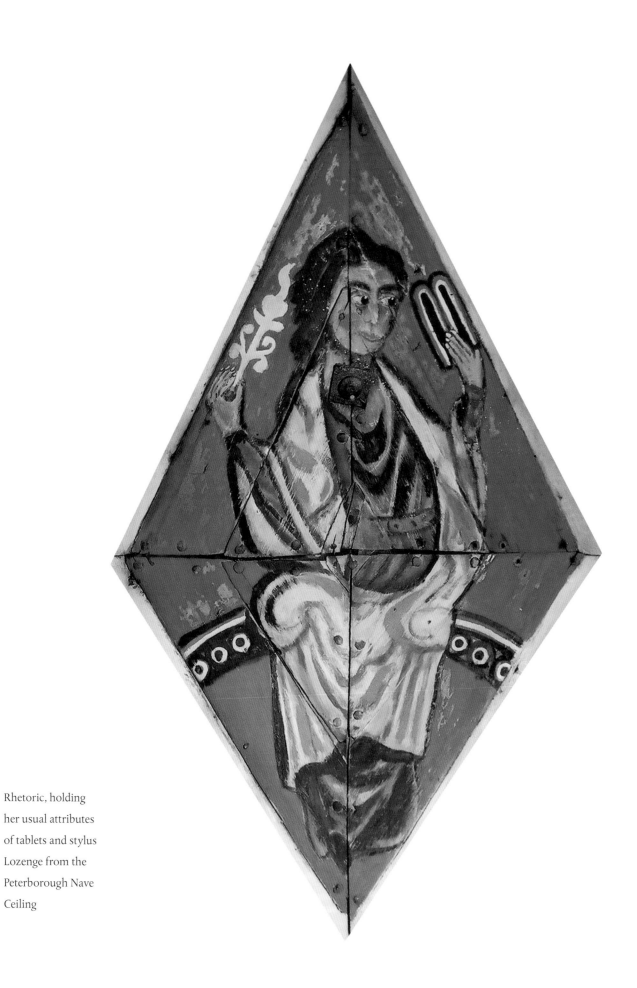

Rhetoric, holding
her usual attributes
of tablets and stylus
Lozenge from the
Peterborough Nave
Ceiling

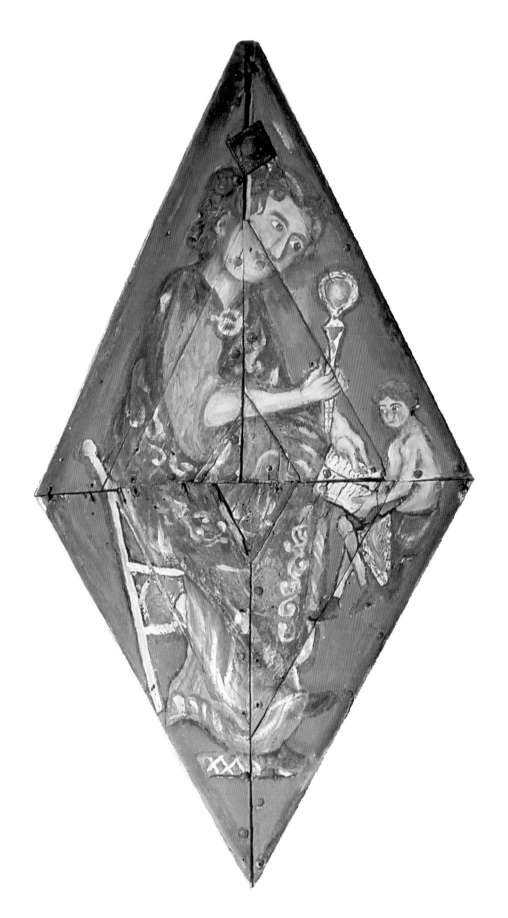

Grammar, holding a
disciplinary palmer
and instructing a
pupil
Lozenge from the
Peterborough Nave
Ceiling

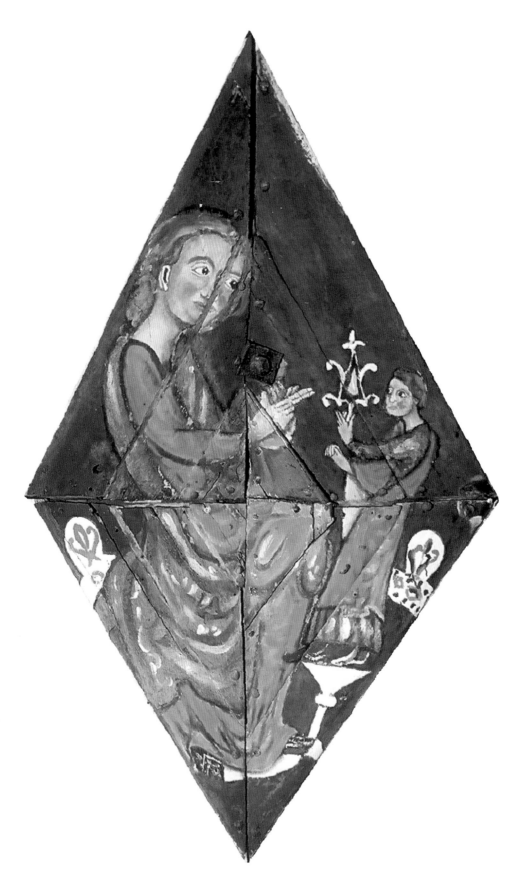

Logic (or Dialectic),
making a gesture of
instruction to a
tonsured clerk on a
pedestal
Lozenge from the
Peterborough Nave
Ceiling

contrary, they were useful in pointing up the truths of Christian morality. Humorous comparison was constructive. And the humour, which frequently involved strange combinations of the good and the bad, the beautiful and the ugly, was often based on a traditional satirical language. The whole concept of nonsense, wit and satire, owed much to what we might call the 'high' literary culture of the educated. Indeed, it too went back to Rome. Today the strangeness of many medieval images on the margins – or indeed, as at Peterborough, quite near the centre – brings to mind the free association of Monty Python, the Surrealists, and notions of the Unconscious derived from Freud. The popularity of the images in the newly discovered fourteenth-century Macclesfield Psalter, now at the Fitzwilliam Museum in Cambridge, is proof of our love of medieval humour. But we must be careful not to confuse our ideas of free thinking with the medieval mind, which had its own sort of wit. If the monks had really meant these antics to be for the people in the Nave, they would not have put them at the end enclosed by the choir, the least accessible to the folk. The humour here is monkish.

Attitudes to music are a case in point. What we call the 'choir' of the church was, and still is, the centre of its musical life in the service of God. Turning again to the ceiling, to the east of the *trivium* and to either side of the easternmost kings and bishops, we find four musicians including a cornet-blowing angel, a fiddler and a dulcimer player. Musical imagery became a popular topic in Gothic church art from the thirteenth century onwards because it could be used to illustrate the dichotomy of good and evil. The first musicians we encounter on the ceiling are 'good' musicians, exactly of the type found in the borders of *Beatus* pages in contemporary Psalters. It is unwise to attach too specific a significance to individual instruments, as such meanings were defined to a significant extent by context, as at Peterborough. For some reason, from about 1240, depiction of musical instruments as attributes of angels became fashionable in England. The sculptures of the triforium at Worcester Cathedral of about 1225–50, the vault paintings in the eastern transepts at Salisbury Cathedral, its sculpted pulpitum also of about 1240, the sculptures of the north transept of Westminster Abbey of about 1250 and the Angel Choir of Lincoln Cathedral, erected 1256–80, are all witness to this new imagery of the musical angel. Peterborough's single musical angel belongs exactly to this fashion, and confirms the idea that the makers of the ceiling were in touch with ideas emerging towards the middle of the century elsewhere in England. The iconography of the Psalms will have been especially important in encouraging this positive view of music, since the Psalms helped to justify the presence of good music in the praise of God.

The words Psalm and Psalter owe their origin to the Latin word *salire*, meaning to leap or dance. Interestingly, our sense of the word 'salacious' (lustful, lewd)

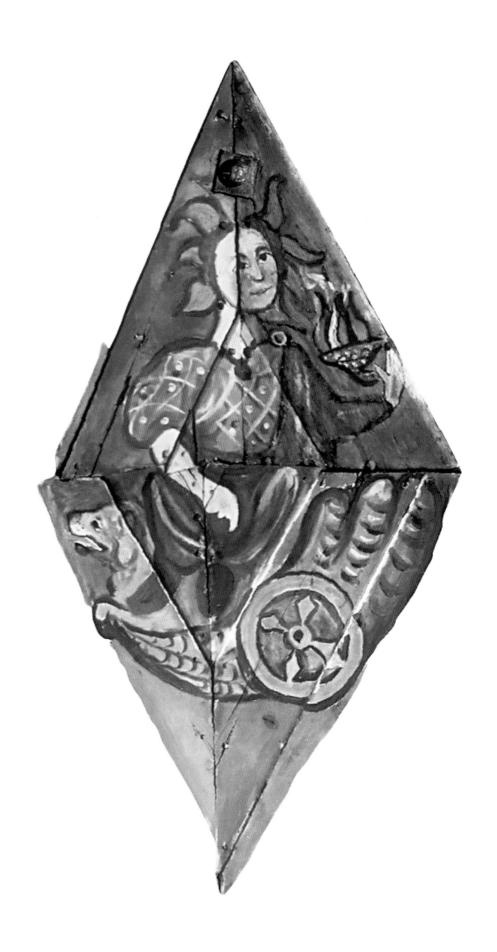

Sun, riding in a
chariot
Lozenge from the
Peterborough Nave
Ceiling

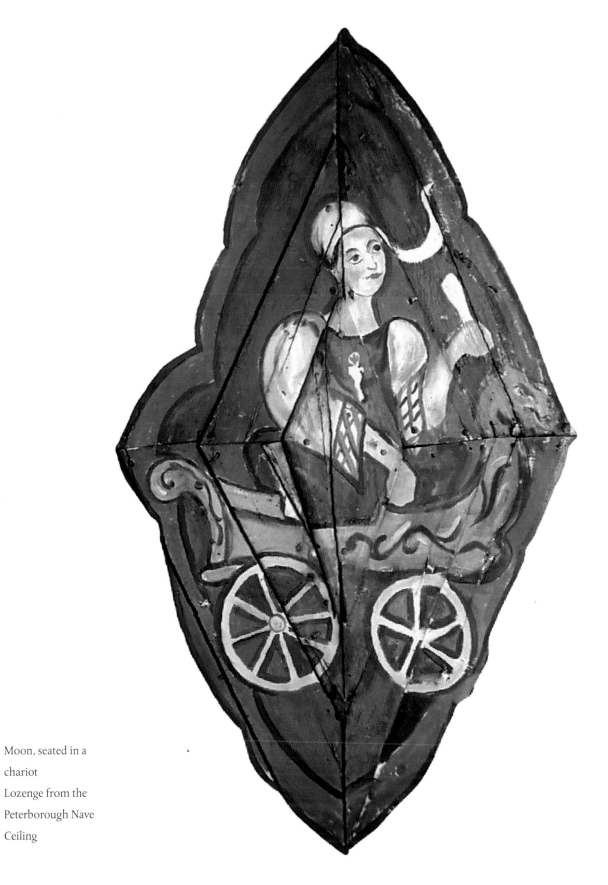

Moon, seated in a
chariot
Lozenge from the
Peterborough Nave
Ceiling

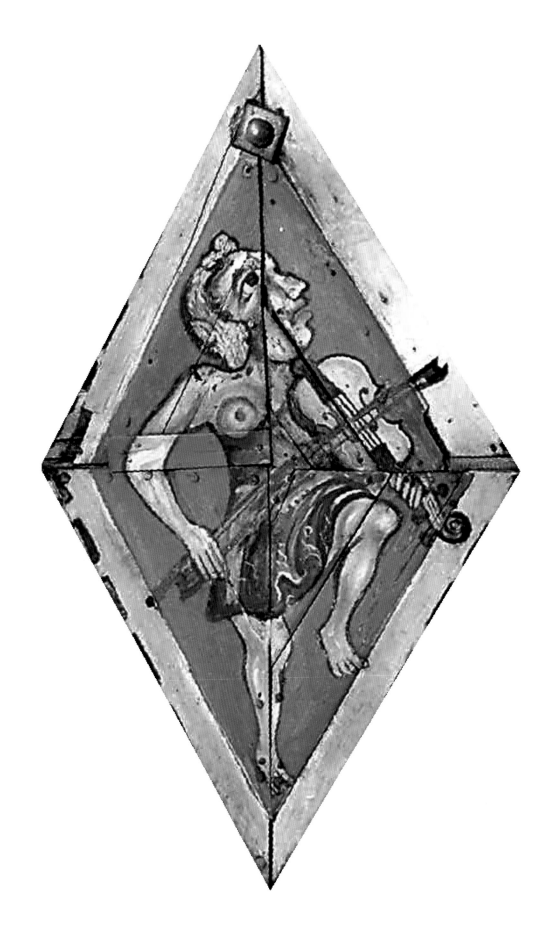

Fiddler
Lozenge from the
Peterborough Nave
Ceiling

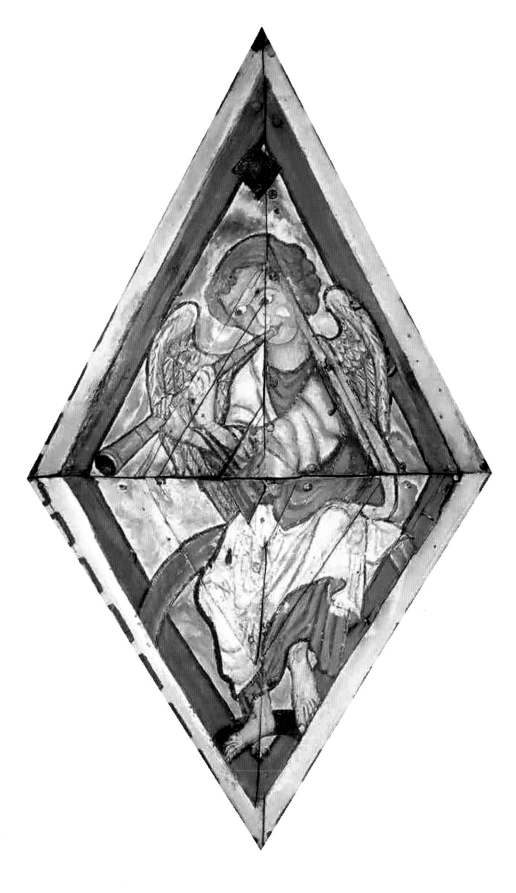

Cornet-blowing
angel
Lozenge from the
Peterborough Nave
Ceiling

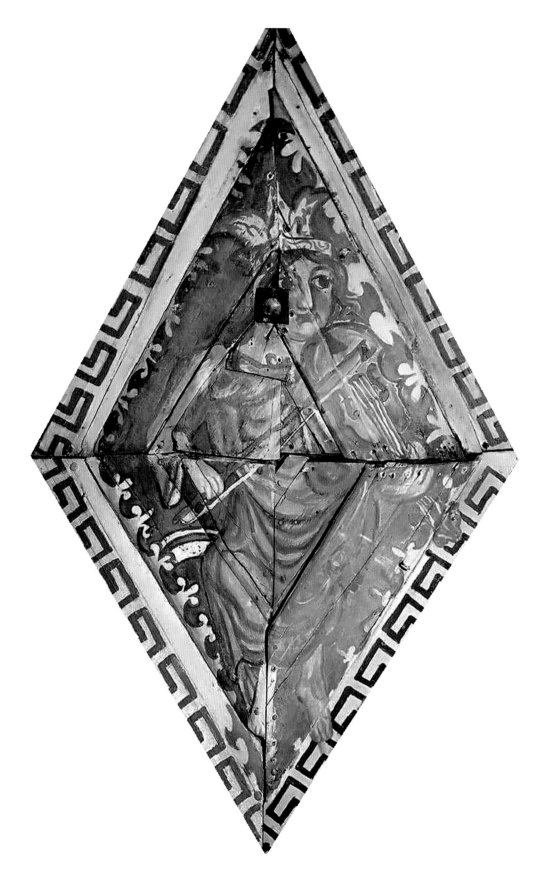

Fiddler
Lozenge from the
Peterborough Nave
Ceiling

is derived from the same word. Indeed, there was also such a thing as 'bad' music as well as the ideal of heavenly music which led men to good. The 'ideal' music of the *quadrivium*, a music of eternal intervals and ideal harmonies, ordered the Christian universe and was a sign of the divine plan. Since Plato, however, many thinkers had regarded performed music as a potential evil because it was sensual in nature. The Christian Church inherited these ideas, and remained cautious in the kind of music it would allow in church. This usually meant that monophonic singing (plainchant) was allowed, but musical instruments played by musicians were not. Musicians were tradespeople, practitioners of the mechanical arts, who consorted with laypeople in pubs and theatres. Like actors or jongleurs, they meant trouble. Troublesome musicians are found on the ceiling as we near the choir. We pass the image of the apostle Saint Paul, paired with the final lamp-bearing king. Next come the patron of the church, St Peter, and the *Agnus Dei*, or Lamb of God, hemmed in by a circle of demonic figures including much more obviously 'bad' musicians. Last to the east come the doorkeeper, Janus, and a medallion with four lions circling a fish. In a ring around Peter and the Lamb are a monkey riding backwards on a goat and holding an owl; a harp-playing ass; a semi-naked fiddler; an anthropophagus; a pick-wielding demon; and a grotesque winged wyvern-like lizard or dragon. The ass and harp – an image of vanity and stupidity, since an ass cannot play a harp – is known from the fables of Phaedrus as well as contemporary English Psalters. The antics on the ceiling will certainly have been painted with the approval, tacit or otherwise, of the monastic community. This lively but sinister ring-dance of demons, monsters, ass and harp and fiddler related to well-established ideas about pervertable music. Very often the saucy images are more lively than the calm, ordered images of virtue, power and knowledge. The monkey-owl-goat motif, together with a fox, occurs in the top frame of the *Beatus* page of a late thirteenth-century Psalter in Brussels, made for the Peterborough monastery. We might also catch, in the last panel showing four confronted lions also circling a fish, an echo of the Compline Text 1 Peter 5.8, "be sober, be vigilant, because your adversary the devil as a roaring lion walketh about seeking whom he may devour".

The English had a particular love of animal imagery. Many of the great medieval bestiaries or books of animal lore are English in origin. God's creation in all its variety, including the animals, symbolized his purpose. Very often, then, animals in some sense 'spoke' about moral and spiritual meanings. The world was understood as an allegory.

The Peterborough scheme tells the monks what they should and should not do: they should sing the offices of the Church rationally and beautifully, not absurdly like the animals; and their life is to be one of almost constant vigilance in

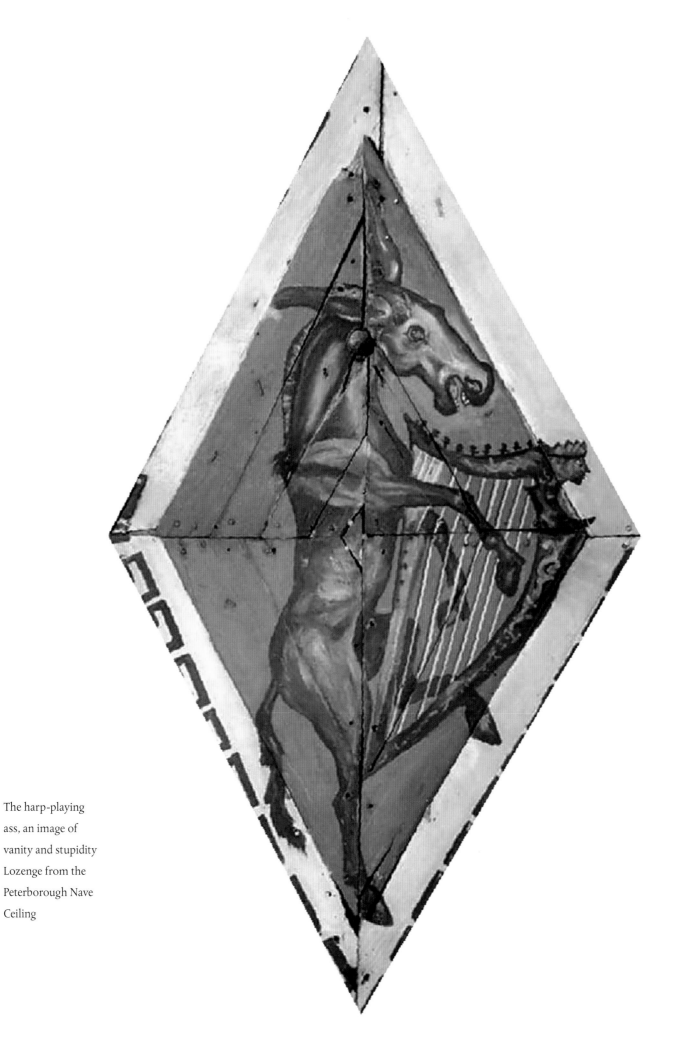

The harp-playing
ass, an image of
vanity and stupidity
Lozenge from the
Peterborough Nave
Ceiling

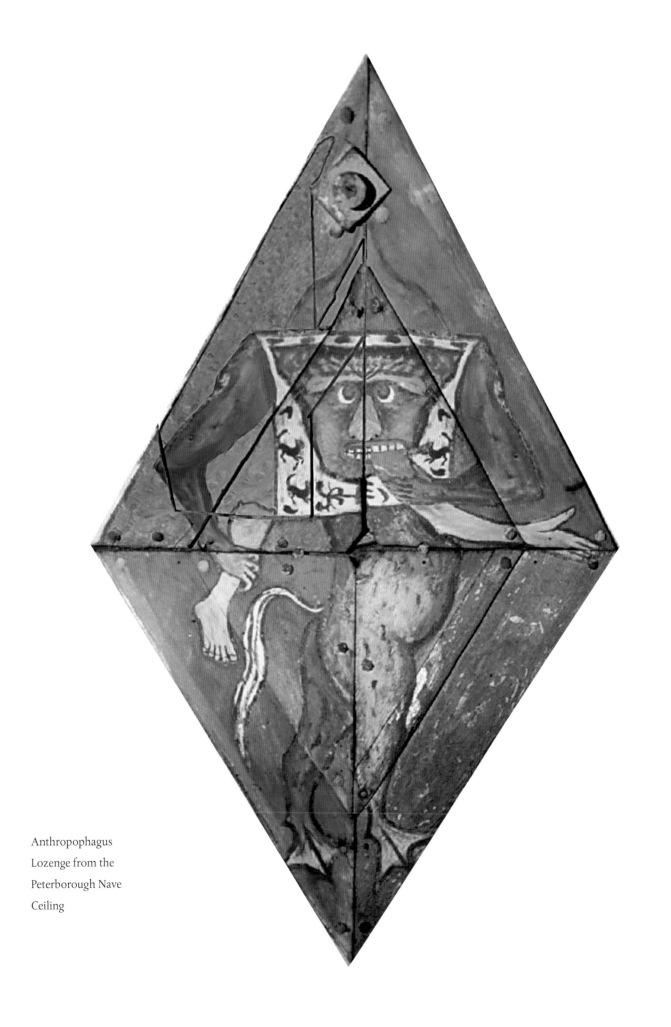

Anthropophagus
Lozenge from the
Peterborough Nave
Ceiling

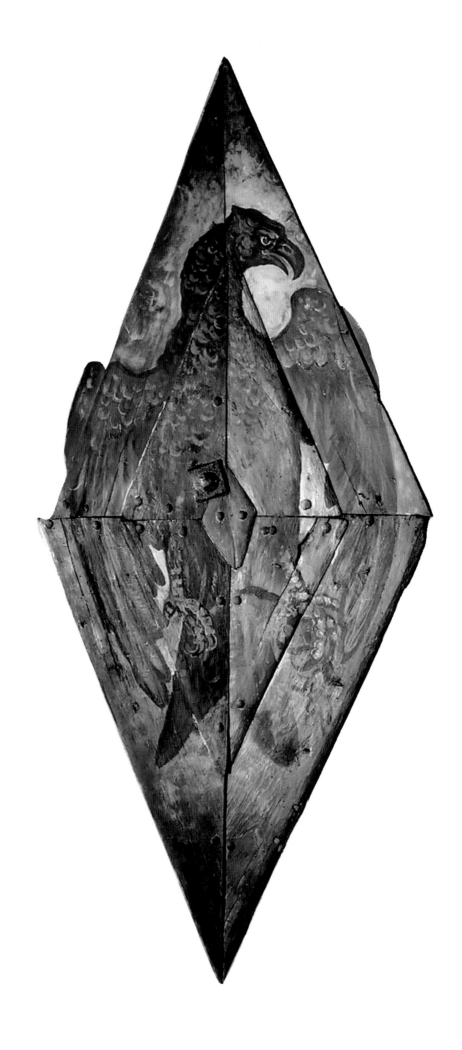

Eagle
Lozenge from the
Peterborough Nave
Ceiling

the face of evil, the threat of which looms close by in the form of the weird creatures on the ceiling near the choir. The borderlines between good and evil had to be policed carefully. Did the Nave, intended for laypeople and for processions, symbolize the 'world' in its most threatening form? Perhaps so, for at the very heart of the east end of the ceiling we find, in a sense, a frontier or stand-off between good and evil. The kernel of this end of the ceiling is the *Agnus Dei* – Saint Peter combination. The Lamb with chalice and cross-staff is one of the best preserved and possibly one of the earliest images on the ceiling – its drawing is tight and lithe and is much in the spirit of the *c.* 1220 group of Peterborough Psalters. The image of the Lamb occurs on the boss in the choir-crossing at Canterbury. Here, it is framed by images of vice, whose importance is such that they have been promoted to the ceiling's central spine. We note how these images coordinate with the original layout of the choir beneath, which can be ascertained partly by examination of the Nave walls, and partly by evidence for the layout of the choir screens. The Agnus Dei was placed directly, and appropriately, over the thirteenth-century position of the rood loft, great Cross and altar. The Janus figure thus presided over the mouth of the pulpitum (a screened passage leading the monks out of the choir into the cloister); Janus controlled the threshold *janua* (doors, arched passageway) beneath. Saint Peter as *janitor coeli*, or keeper of the keys of Heaven and Hell, would thus have guarded the paradise, symbolized by the choir, against the forces of evil, represented by the horrible images pressed together at this end of the ceiling.

It is worth considering the possibility that the typological pictures of the Old and New Testament which were later recorded in the choir – by their inscriptions proved to be similar to the typological glazing executed at Canterbury in the late twelfth century – were part of the refurnishing of the choir undertaken by Abbot Walter in the period that the ceiling was begun. Though very different – indeed perhaps deliberately opposed – the choir and ceiling paintings fundamentally formed one programme, the choir demonstrating the divine order of biblical revelation, the ceiling the hazards and joys of the religious life.

The Nave Ceiling of Peterborough is one of the most important witnesses to the art of medieval English monasticism. Its combination of topics is unique, although it is unclear if it was derived from somewhere else, like Canterbury, and whether it had much impact elsewhere later on. In fact, the future of painted ceilings was not to be a distinguished one. Later examples tend to have heraldry or patterns. The future lay with another art form which could only have developed with the rib vault, namely the sculpted boss or keystone. These bosses were starting to appear in English Gothic churches at around the same time as the Peterborough ceiling was being painted, for instance at Worcester Cathedral,

Agnus Dei
Lozenge from the Peterborough Nave Ceiling

where they occur on an important scale for the first time. Ely has them, and so does Westminster Abbey. By the fourteenth and fifteenth century they were to be found throughout Norwich Cathedral in their thousands. Perhaps the Peterborough ceiling is witness of an important moment of transition, from the age of the great painted ceiling to that of the carved vault boss.

Above all, the ceiling tells us much about the way the Peterborough monks related ideas to one another: power, knowledge, morality were connected, and the highest ideas of order – Church and State, the Liberal Arts and the hierarchy of the saints – were consciously combined with the deliberately nonsensical. As well as being fond of animals, the English are traditionally fond of nonsense, a fact exemplified by the nonsense literature produced between the sixteenth and nineteenth century which survives today in nursery rhymes. Think of the cat and the fiddle, and of the cow jumping over the moon, or the owl and the pussycat sailing away. Though we think of these as being part of the culture of the people, they may have had origins elsewhere. Indeed, it has been said that the tradition of nonsense may have originated in educated and elite places like the Inns of Court in London, and in the universities – places where clever young men who were forced to live in close proximity shared the 'in jokes' beloved of institutional life. Our ceiling hints at the possibility that medieval monks were much the same.

FURTHER READING

P. Binski, 'The Painted Nave Ceiling of Peterborough Abbey', in *The Medieval English Cathedral. Papers in Honour of Pamela Tudor-Craig*, ed. J. Backhouse, Harlaxton Medieval Studies, 10, Donnington, 2003, pp. 41–62

P. Binski, *Becket's Crown. Art and Imagination in Gothic England 1170–1300*, New Haven and London, 2004

C.J.P. Cave and T. Borenius, 'The Painted Ceiling in the Nave of Peterborough Cathedral', *Archaeologia*, LXXXVII, 1937, pp. 297–309

M.R. James, 'On the Paintings Formerly in the Choir at Peterborough', *Proceedings of the Cambridge Antiquarian Society*, IX, new series 3, 1894–98, pp. 178–94

N. Malcolm, *The Origins of English Nonsense*, London, 1997

F. Nordström, 'Peterborough, Lincoln, and the science of Robert Grosseteste: a study in 13th century architecture and iconography', *Art Bulletin*, XXXVII, 1955, pp. 241–72

L. F. Sandler, 1970, 'Peterborough Abbey and the Peterborough Psalter in Brussels', *Journal of the British Archaeological Association*, new series, XXXIII, 1970, pp. 36–49

E.W. Tristram, *English Medieval Wall Painting. The 12th Century*, Oxford, 1944

E.W. Tristram, *English Medieval Wall Painting. The 13th Century*, Oxford, 1950

Shield from the west end of the
Peterborough Nave Ceiling

Survey control

At the time of the survey, December 1996, no fixed survey grid existed around the cathedral. Twenty temporary survey stations were therefore set out on a local grid on the triforium, from which observations to control stereo-pairs could be made. Using an EDM, the traverse from the triforium was brought up into the roof space, providing a common three-dimensional control system. Main stations were laid out along the central walkway of the roof and satellite stations were placed to allow a field of sight down the sloping panels to the inaccessible wall-head. It was essential to use the same control system for the roof survey as that used for the ceiling.

To enable each of the twenty-two stereo-models to be orientated in an analytical stereo-plotter or a digital photogrammetric workstation, a minimum of four control points per model was required. Because of the difficulty of placing plastic targets on the ceiling it was decided to use points of detail, even though these would not provide the same clarity of pointing and hence level of accuracy as a target and would also take longer to observe. The wide platform at triforium level was used for surveying the control points by intersection, as it provided both an excellent view of the ceiling and reduced the need for any extreme vertical angle observations. To allow the intersections to be carried out effectively colour prints were made from the stereo-photography and marked up directly on site, as detail points were selected. A total of eighty-five points of detail were coordinated. This meant that there were up to six points available per model. Normally only four points per model are required so these extra control points helped ameliorate the reduced accuracy that was a consequence of using solely detail points.

Stereo-photography

The cathedral ceiling is 25m above ground floor level. In order to acquire stereo-photography of a suitable negative scale it was necessary for the English Heritage Metric Survey Team to use either access equipment or a camera with a telephoto lens. The use of access equipment was rejected for two reasons. First, there was the physical difficulty of bringing a scaffolding tower or hydraulic lift into the cathedral. Secondly, the photography had to make use of

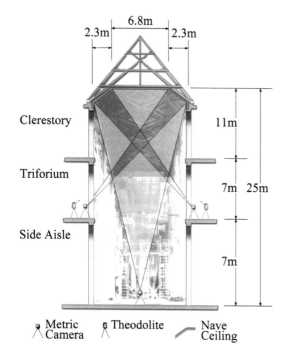

A diagram showing the camera and theodolite set-up positions that were used to take and control the stereo-pairs.

available light, since artificial methods would not have given adequate illumination over the whole ceiling. The long exposure times thus involved made the use of access equipment impossible, as it would not have been sufficiently stable. The decision was therefore taken to use a Zeiss UMK 30/1318 metric camera for the photography.

The 5in. x 7in. format and 300mm lens of the UMK meant that the entire width of the ceiling could be covered in one photograph taken from the ground floor. The resulting negative scale of approximately 1:80 was sufficient to allow the production of drawings at 1:20 or even 1:10. The camera and tripod were mounted on a 'dolly' and wheeled down the centre of the Nave, making possible a run of twenty-three photographs and thus twenty-two stereo-

A stereo-pair of the Nave Ceiling

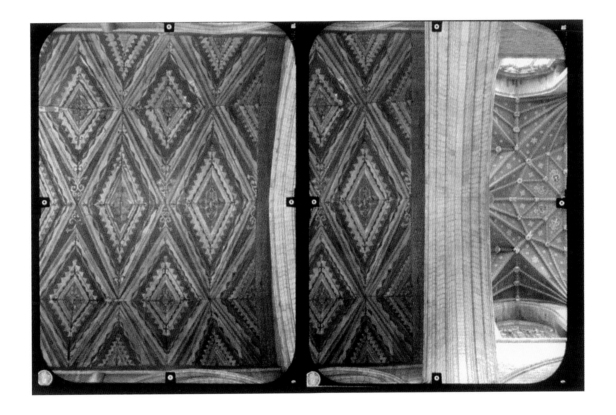

models. In addition to this ground-based photography, stereo-imagery was taken from the triforium using a 5in. x 4in. format WILD P31 metric camera with a 100mm lens in order to cover the two canted side sections of the ceiling, but in the end this was not required owing to the excellent coverage provided by the ground-based photographs.

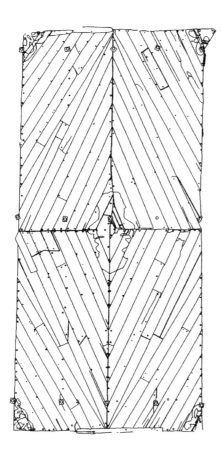

A photogrammetric plot of four of the thirteenth-century ceiling panels. The plot contains ferrament and painted detail.

Photogrammetry

The initial requirement of the project was a set of photogrammetric line drawings. These were to be plotted on A1 + sheets at a scale of 1:20 and were to cover the architectural detail within the first 7m of ceiling at the eastern end of the Nave – which was to be the extent of the first phase of conservation works. In addition, a set of A3-format drawings at the larger scale of 1:10 were needed during the actual conservation works on site to enable all the visible structural features such as nail heads, screw threads and tie bolts, as well as the painted detail itself, to be referenced.

In discussion with the conservation consultant and architect, the precise level of detail for the survey was agreed. All of the detail was recorded according to the English Heritage standard specification, although the CAD layering convention was reduced down to three layers – boards, fixings and painting. During this initial plotting work some interesting problems arose.

The first was how best to represent each of the oak boards that made up the actual ceiling. As each board overlapped its neighbour it was impossible to record accurately all four sides, as one side was usually hidden from view. It was therefore decided that where part of a board was hidden by the overlap of another, the visible edges only would be plotted as an unclosed three-dimensional polyline.

Secondly, as some of the painted detail was difficult to interpret successfully as a line, particularly when viewed at high magnification, it was decided to plot this detail as a basic outline only and to infill this outline with a scaled photographic image.

Using this initial plotting work as a benchmark, an accurate estimate was provided to the architect of the cost involved in photogrammetrically processing the remaining 55m of ceiling to the same level of detail, using the stereo-photographs and survey control data provided by the English Heritage Metric Survey Team. This information was used by the Dean and Chapter to procure the rest of the plotting work.

The use of orthophotography

As noted above, little of the painted detail was to be recorded as line work. Instead, a scaled photographic image was to be utilised and it is here that the application of digital photogrammetric techniques, in particular the ortho-photograph, was to become crucial to the documentation of the project

The colour negatives were scanned at 22.5-micron resolution using a photo-

grammetric scanner, producing files of approximately 120 MB each. These were imported into a Helava digital photogrammetric workstation, running SOCET Set software, and processed to form a digital orthophotograph of the ceiling at 5mm pixel resolution with a file size of 90 MB.

The major difficulty encountered during this project was the colour balancing of the twenty-three colour images used during the production of the orthophotograph. Even though geometrically correct scans were utilised, the slight negative caused by the use of natural light appeared to have upset the automated scanning process usually employed during the scanning of aerial imagery. This resulted in individual scans that were incorrectly colour balanced and that, when joined together, produced a very fluctuating colour image even after processing with Adobe PhotoShop®. Eventually the photographs were re-scanned using Kodak Photo-CD in an attempt to produce colour images that could be evenly joined together.

Extracts from the complete orthophotograph were provided in digital form for the conservators working on the scaffolded ceiling. These images were imported into Corel-DRAW running on laptop computers to provide a backdrop to the line drawings, which were converted from the DXF format. The conservators annotated the drawings while on site.

Abstracted from the English Heritage publication *Measured and Drawn*, Swindon 2003

A plot of part of the orthophotograph overlaid with the photogrammetric line drawing and subsequently annotated by the conservators. Using the orthophotograph and the line drawing, the conservators were able to work from an image of the ceiling as well as the outline physical structure of the boards.

Contractors Involved in the Restoration Process

A1 Steel Limited

Abel Alarm Company Limited

B&H Syscom Limited

Bard Electrics Limited

BDS Fire & Security

Beebys Limited

Ian Campbell Partnership

Clivedon Conservation Workshop Limited

Cunningham Lindsey UK

B L & J Doré of Textile Cleaning and Conservation

Ecclesiastical Insurance Group plc

Charles Farris Limited

GBF Masonry Cleaning Services Limited

Gleeds

Dr Nick Hadgraft

Harrison & Harrison Limited

Hugh Harrison Conservation

Henwood Church Supplies Limited

Jellings Builders Limited

K.C.M. Electrical Contractors

Kimbolton Restoration Limited

Gillian Lewis, Conservation Adviser to the Chapter

Julian Limentani of Marshall Sisson, Architect

John Lucas (Peterborough) Limited

Makin Organs Limited

Max Access Limited

Merlin Services Limited

Nilfisk-Advance Limited

The Perry Lithgow Partnership

Peters Cleaners Limited

Reclaim

Rentokil Initial plc

Riverside Studio

T N Rose & Partners

Royale Carpets (East Anglia) Limited

Sandler Seating Limited

Geoffrey Sayers MBE

Skillington Workshop Limited

Sotham Engineering Services Limited

Tankerdale Limited

The Textile Conservation Centre

Kenneth Tickell & Co Limited

Tobit Curteis Associates

O. Toffolo & Son Limited

Drs Cathy Groves and Ian Tyers
of the Department of Archaeology, University of Sheffield

Vertical Technology Limited

Vertrix Living Communications

Walbrook Associates Limited

The Wall Paintings Workshop

Photographic Acknowledgements

The Trustees are especially grateful to the following
for making available photographs in their copyright for use in this book:

The Architects' Journal
BBC Look East
Cambridgeshire Fire & Rescue Service
English Heritage
The Fitzwilliam Museum, Cambridge
Harrison & Harrison Limited
Hugh Harrison Conservation
The Perry Lithgow Partnership
Peterborough City Council
Peterborough Evening Telegraph
Bob Rixon
Stuart Rixon
The Society of Antiquaries
The Textile Conservation Centre

They also record their appreciation to Bob Laughton
for his professional photographic work, and to the following,
whose photographs also appear in this book:

Elizabeth Knight
Geoffrey Sayers
Andrew Watson
Andrew Whelan